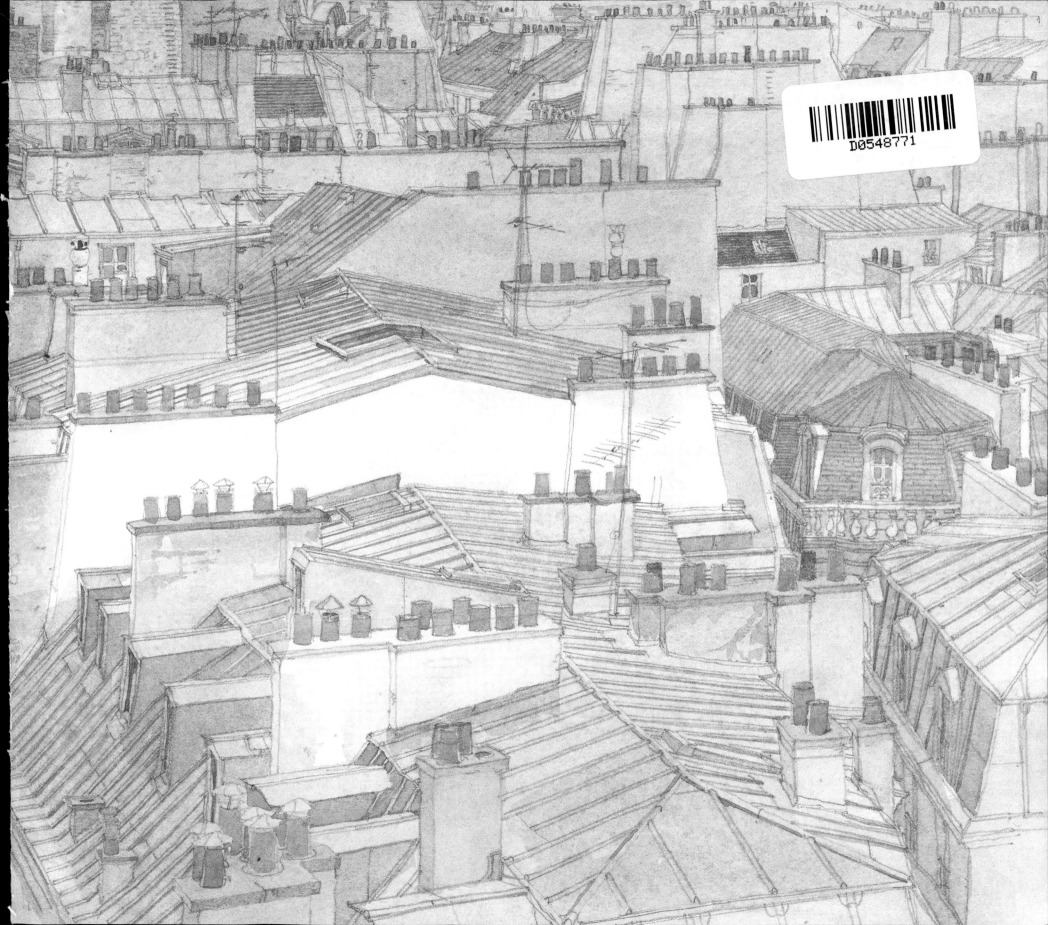
D0548771

Paris

sketchbook

Jacket illustration: The Ile Saint-Louis seen from the Quai des Grands Augustins.
Page 4: Statue of the Marquis de La Fayette in the Tuileries gardens.

Paintings © Fabrice Moireau 2001
Text, design and typography © Editions Didier Millet 2001

All rights reserved

Printed in Italy

No part of this book may be used or reproduced in any
manner whatsoever without written permission except in the
case of brief quotations embodied in critical articles or
reviews. For information, address
St. Martin's Press, 175 Fifth Avenue, New York, N.Y. 10010

First published in French as *Paris Aquarelles* by
Les Editions du Pacifique, 5 rue Saint-Romain, 75006 Paris

Designers Jérôme Faucheux and Nelani Jinadasa
Colour separation by Colourscan Co. Pte Ltd, Singapore
Printed by Artegrafica S.p.A., Verona

ISBN 0-312-28416-0
First U.S. Edition: November 2001
Reprinted 2002, 2003

10 9 8 7 6 5 4 3

Paris
sketchbook

Paintings FABRICE MOIREAU *Text* MARY A. KELLY

Captions translated from those originally written in French by YVES SIMON

ST. MARTIN'S PRESS
New York

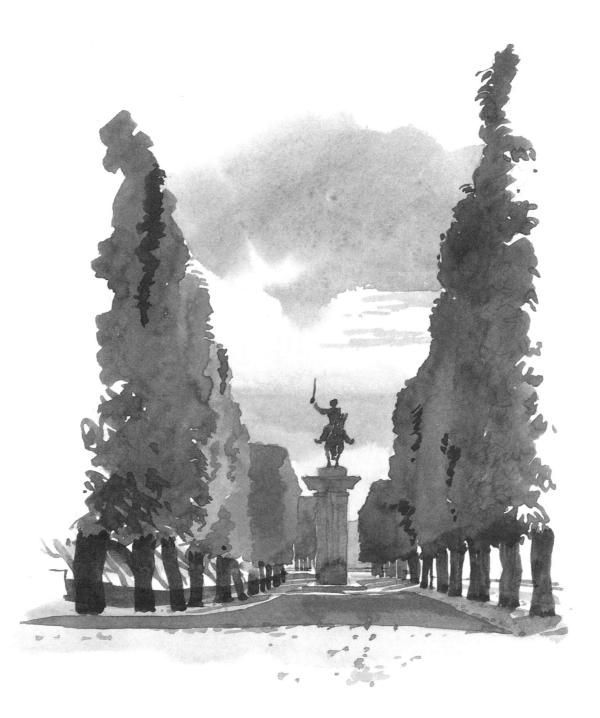

Contents

Introduction

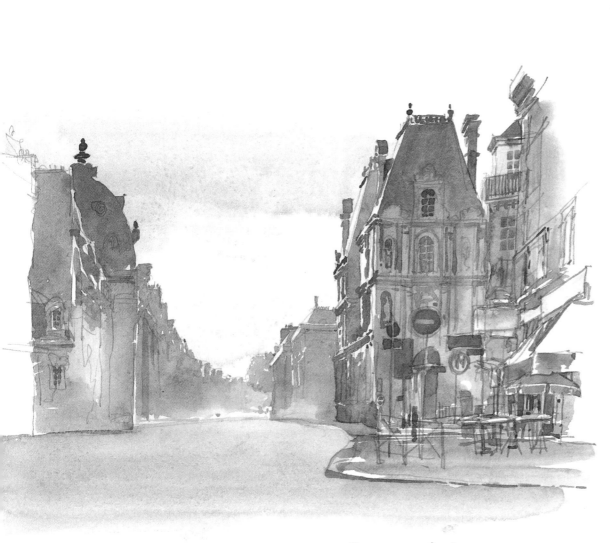

Rue de Rivoli, 7:30 a.m.,
Wednesday, September 8, 1999.

Everyone develops his or her own personal relationship with Paris. It begins with a visit, a book or a film, but then it seems to take on a life of its own. We can't get enough of the architecture, the art, the history, the food, the wine, the shopping, and the sensations we experience just walking the streets. But the more we visit or the longer we live there, the more our initial impressions evolve and deepen. We reach a more mature understanding of the city, how it works and our place in it. And then, just when we think we have it all figured out, Paris startles us again with its beauty, its depth or some side we never knew.

Paris is a special city, a place one feels privileged to live in or visit. We forgive the rainy weather and grey skies because there are so many qualities to love – the Seine, the buildings, the avenues, the parks, the cafés. There are also the intangibles: the energy that draws interesting, creative and dynamic people to the city and then throws them together in brilliant combinations; the light, which is often not bright enough to inspire the joyful feeling of a sunny day, but which in its dim moodiness seems to leave us open to so many other emotions.

Paris is a highly personal city, which makes the contrast between daily human experience and the architectural grandeur around us all the more striking. Pleasant moments are intensified. Oscar Wilde once said: "When they die, all good Americans go to Paris." The same could be said of many other nationalities, for Paris seems to belong to everyone.

First Impressions

Many first impressions of Paris come from books, movies, art, food and fashion. In school, we are introduced to the writings of the great French authors and the famous expatriates who were once part of Paris's legendary literary scene. In art history classes and museums around the world, we discover the work of the French Impressionists, the Cubists, the Dadaists and the Surrealists. There are also the artists of myriad nationalities who flocked to Paris and the French countryside to paint. Who can forget the first time they stood face to face with Van Gogh's "Starry Night" in New York City's Museum of Modern Art or Monet's enormous tableaux of waterlilies? The colors, the images, the moods and the passion all leave lasting impressions on our souls, impressions that are ultimately linked to Paris.

Then there is the food. Wherever one grows up, the finest restaurants in town are usually French. We go to them as a reward or on special occasions such as a graduation, a birthday, an engagement or a wedding anniversary. Paris and its food and wine are linked to romance and achievement (and perhaps a healthy dose of pretension). Meanwhile, in our households, our mothers or sisters may keep a highly regarded copy of Julia Child's *Mastering the Art of French Cooking*. Even at home, whether in America, Europe or Asia, the tastes of France – and by popular association Paris – are not too far from our reach.

Our favorite fashion magazines such as *Vogue* or *Elle* often take their names from the French language. They follow the haute couture shows in Paris, distilling their meanings for us in glossy spreads of clothes we can wear in our own cities. On television and in photographs we see celebrities from our own cultures dressed by the prominent French couturiers of the moment. Paris is linked to beauty, to fine things, to success and to prestige. In our buildings and monuments we also see the influence of the French. The Statue of Liberty, symbol of the USA, was a gift from the French in 1885 and the work of a French sculptor Frédéric Auguste Bartholdi with design help from Viollet-le-Duc and Gustave Eiffel. In more recent years, the modern urban designs of Philippe Starck have invaded our cities in home furnishings and in the dramatic interiors of trendsetting hotels and restaurants in New York, Los Angeles, Miami, London,

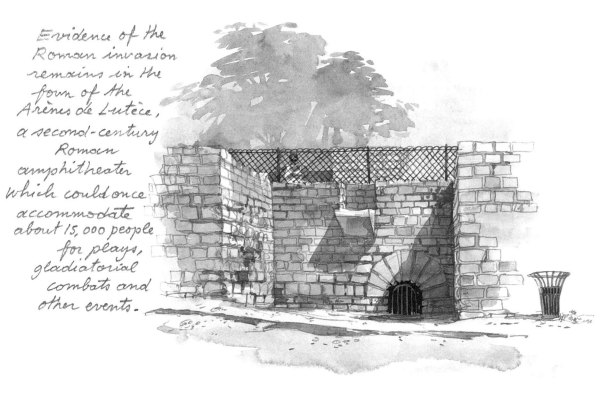

Evidence of the Roman invasion remains in the form of the Arènes de Lutèce, a second-century Roman amphitheater which could once accommodate about 15,000 people for plays, gladiatorial combats and other events.

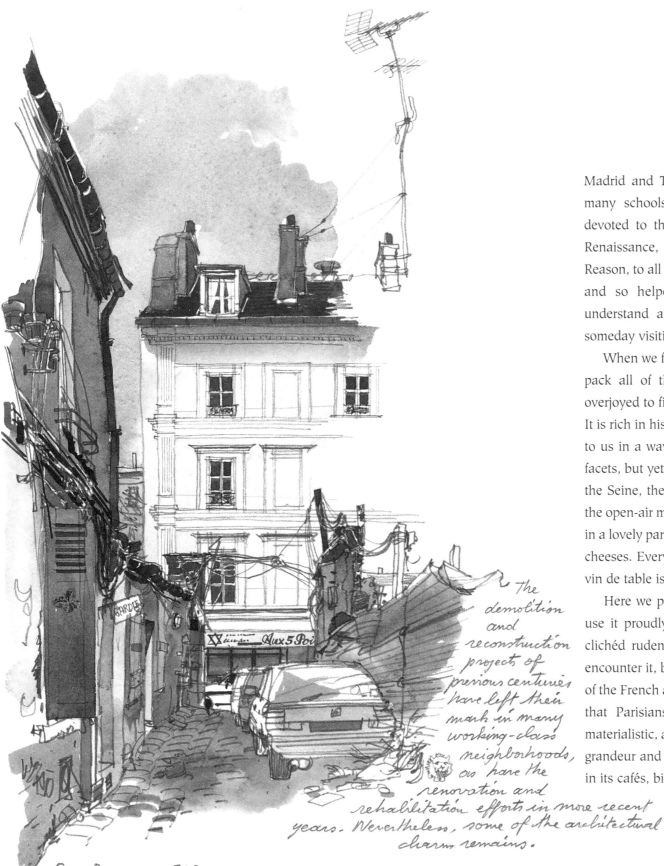

the demolition and reconstruction projects of previous centuries have left their mark in many working-class neighborhoods, as have the renovation and rehabilitation efforts in more recent years. Nevertheless, some of the architectural charm remains.

Rue Denoyez, 20e.

Madrid and Tokyo. The French language is a requirement in many schools around the world. Entire history classes are devoted to the French Revolution and concepts such as the Renaissance, the Enlightenment, Romanticism and the Age of Reason, to all of which the French made important contributions and so helped shape the modern world. We struggle to understand all of these things from afar and we dream of someday visiting Paris where we hope it will all make sense.

When we finally do make our first trip to the City of Light, we pack all of these impressions and expectations and we are overjoyed to find that the city does not disappoint. It is magical. It is rich in history and in jaw-dropping vistas. We feel it belongs to us in a way because we have grown up with so many of its facets, but yet there is so much more to discover. The museums, the Seine, the famous avenues and shops. We want to explore the open-air markets and cook up a French meal or simply picnic in a lovely park with a crusty baguette and an assortment of fresh cheeses. Everything tastes so much better in Paris! An ordinary vin de table is a delight.

Here we probably know some of the local language and we use it proudly, or perhaps with some timidity. We expect the clichéd rudeness of a Parisian waiter and we smile when we encounter it, but we are also pleasantly surprised by the warmth of the French and their joie de vivre. It quickly becomes apparent that Parisians value the sensual pleasures of life over the materialistic, although the latter is not absent. Paris is laden with grandeur and monumental beauty, but there is also an intimacy in its cafés, bistros and passages.

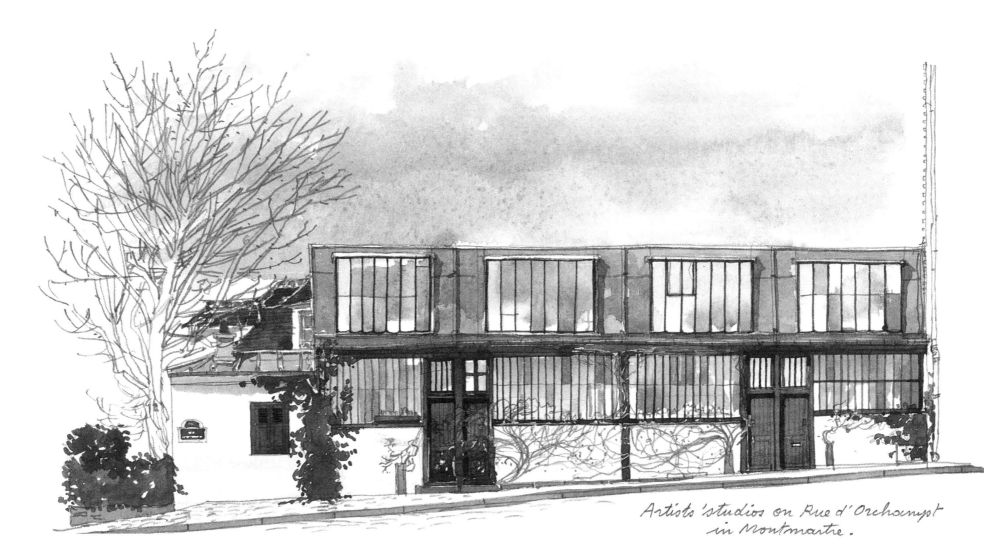

Artists' studios on Rue d'Orchampt in Montmartre.

Left Bank, Right Bank

Named by Julius Caesar, the Seine runs 776 kilometers from Burgundy through the heart of Paris to the English Channel. Paris was born on this river, on the tiny island now called Ile de la Cité where the Romans settled in the 1st century B.C. Dependent on the river for fishing and trading, the Romans were followed by generation upon generation who enjoyed and profited from its waters. The city's history has been intertwined with the river ever since. When the Vikings invaded Paris in the 9th century, warships crowded the Seine like a congested highway. During the bloody St Bartholomew Day massacre of Protestants in 1572, dead bodies coursed along its waters, winding their way through the city. Parisians have washed their clothes in the Seine, swum in it and thrown their refuse it in. Henry IV even bathed nude in it in the early 17th century. In the early 1800s, Napoleon Bonaparte built a canal system in an effort to bring cleaner water to the city and create a short-cut.

Today, as we gaze upon the Seine, those events are obscured by the river's sheer beauty. Modern methods of water treatment have made it cleaner. There are pike and bream in the river and

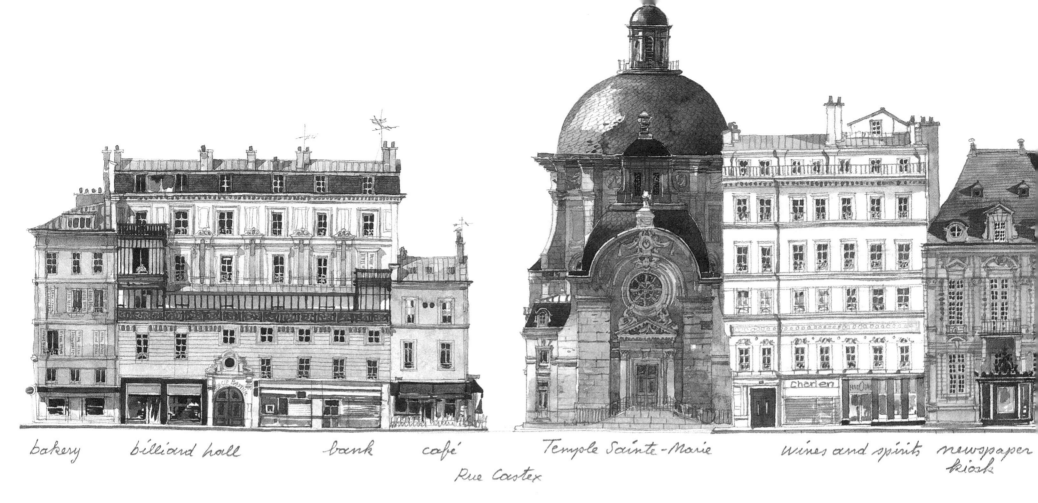

bakery billiard hall bank café Temple Sainte-Marie wines and spirits newspaper kiosk

Rue Castex

green plants along its banks. At night, with all the lights and period buildings reflected in the water, a stroll along the quays and bridges is one of the most romantic experiences in the world. By day, browsing among the bookstalls set up along its banks is a memorable way to while away an afternoon.

The Seine also divides the city into "left" and "right", the left bank long associated with the artsy bohemian crowd, the student revolts of 1968 and the Sorbonne. The right was traditionally more bourgeois, with its business district around the Bourse and working-class neighborhoods. Linked together by 37 bridges and a subway that continuously criss-crosses between left and right banks, Paris has outgrown such generalizations. Trendsetting boutiques and restaurants have

moved into right-bank neighborhoods such as the 1st arrondissement along Rue Saint-Honoré, the streets around Bastille and the converted wine depots of the Bercy area in the 12th arrondissement. The opening of the modern opera house at Place Bastille in 1989 spurred the growth of a lively nightlife there which merges into the late-night scene around the Marais. Further north, a renovation of the historic canals of Saint-Martin, Ourcq and Saint-Denis began in 2000, with plans for river kayaking, and improved quays for cyclists and pedestrians.

Meanwhile, the Left Bank areas of Montparnasse and the Latin Quarter continue to draw a nostalgic crowd, but the avant-garde has moved to Ménilmontant in the Right Bank's eastern 11th arrondissement, at least for now.

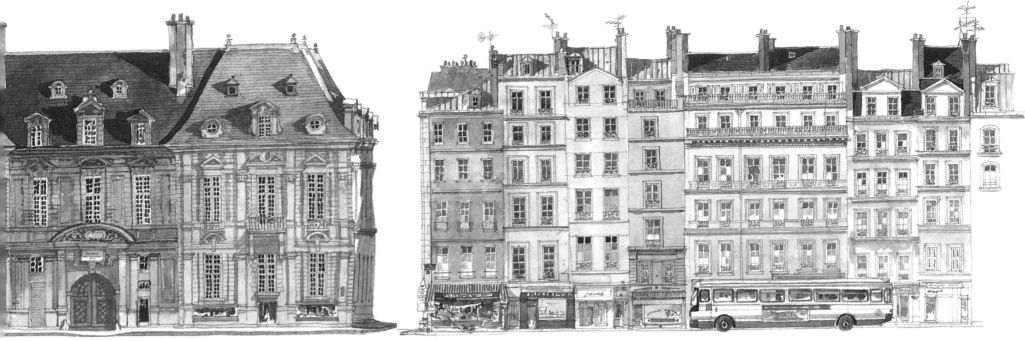

collège des Francs-Bourgeois

pharmacy

Rue du Petit-Musc delicatessen bakery

Fruits and vegetables clothing shop

Bus 69

"Quiet Days in Clichy"

Arthur Miller's story of romantic dalliance is in a long tradition of works which have immortalized the people and places of Paris. Sounds, smells, colors, personalities, revolutions, even Parisian slang have all represented a rich seam of material for writers both French and otherwise. No one brought the characters of Paris at the turn of the 19th century more vividly to life than Honoré de Balzac, in the novel cycle, *La Comédie Humaine*. Victor Hugo wrote of the Paris commune and the siege of the city in his poems "L'Année terrible" (1872) and penned colorful images of human suffering in his epic *Les Misérables* (1862), still recreated on international stages with its unforgettable chase scene through Paris's maze-like streets and sewers.

It was not only the French who found in Paris a source of inspiration. No one contributed more to the popular mythology of the French Revolution, and the Bastille in particular, than Charles Dickens, in *A Tale of Two Cities*. A jaundiced, not to say insular English view of Paris was pungently expressed by one William Cole (*A Journal of my Journey to Paris in the Year 1765*): ". . . if Truth will not make ["a vain & fantastical Frenchman"] acknowledge the Petitesse, the Littleness, the Nothingness of Paris in Respect to the Beauty, Grandeur & Superiority of London, he must be ashamed of nothing; indeed a very Frenchman." But he was outnumbered: Paris has enchanted British visitors from the diarist John Evelyn in the 17th century to P.G. Wodehouse, the creator of Jeeves, in the 20th.

For the British, during much of the last two centuries, Paris has been a place of pleasures and possibilities, somewhere to escape from buttoned-up Victorian values. Oscar Wilde visited Paris for his honeymoon in 1884. He was to return to Paris later, after the Douglas court case, and died there in 1900. Shortly before his death in the former Hotel D'Alsace at 13 rue des Beaux-Arts, he is reputed to have said: "I can't stand this wall-paper. One of us will have to go."

The American novelist Henry James, who worked in Paris in the 1870s, was a forerunner of a peaceable invasion by writers from both sides of the Atlantic in the early part of the 20th century, when Paris attracted such legendary expatriates as James Joyce, Scott and Zelda Fitzgerald, Anaïs Nin and Henry Miller. Indeed, Americans, Irish, Spanish and Russians considered Paris the artistic center of a creative world.

World War I played a part in introducing many young Americans to Paris, many of whom returned after the war – an experience sweetened not only by private incomes in many cases but also a highly favorable exchange rate. But sacrifices were made. The period is described in Hemingway's *A Moveable Feast*, a detailed account of the years he spent in Paris from 1921 to 1926 as a struggling young writer: The book recounts his walks through the 5th and 6th arrondissements, usually between his home on Rue Cardinal Lemoine, the salon of Gertrude Stein on Rue de Fleurus, Shakespeare and Co.'s bookstore then on Rue de l'Odéon and the Brasserie Lipp on Boulevard Saint-Germain.

Many Parisian landmarks have associations with writers and artists. An international cafe society thrived at Les Deux Magots

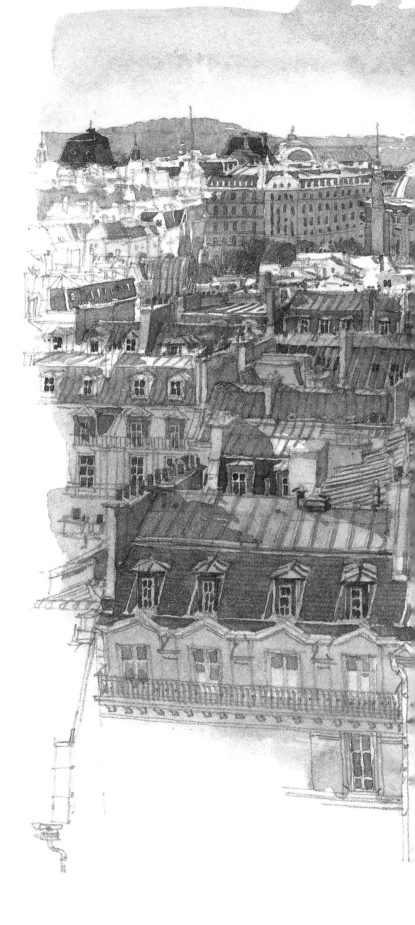

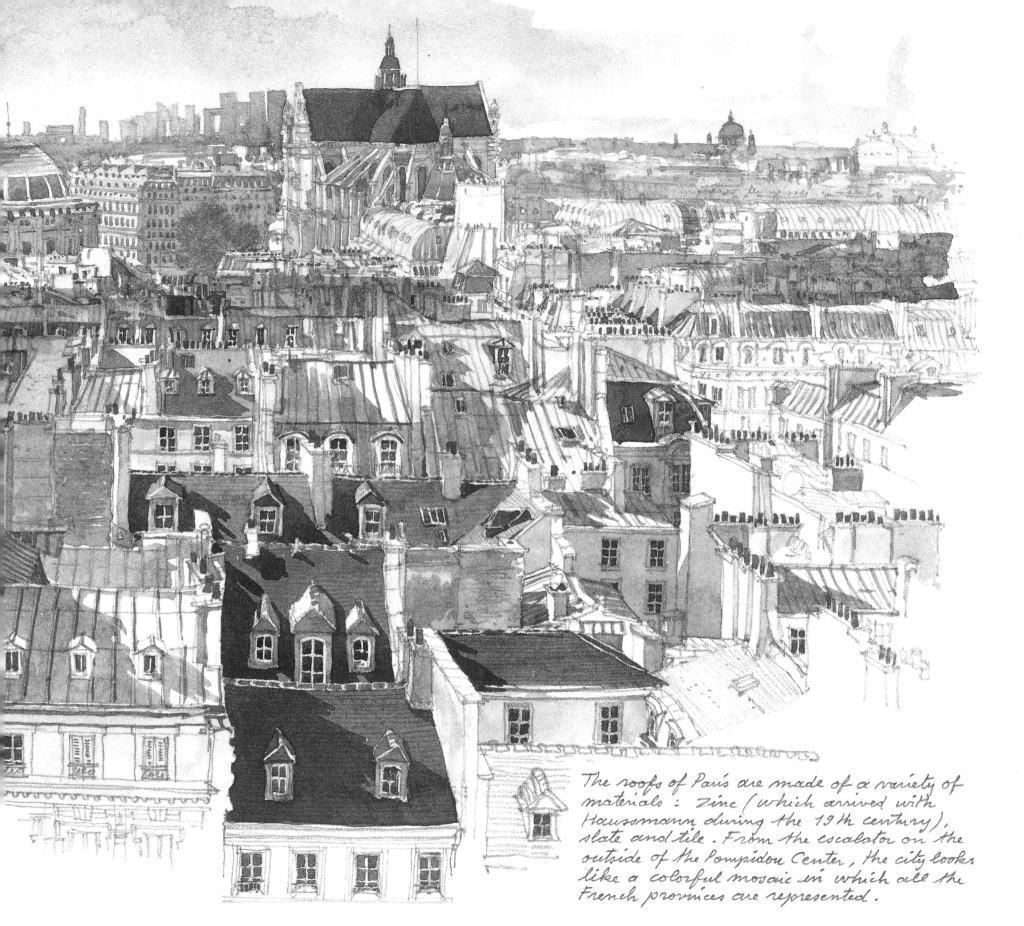

The roofs of Paris are made of a variety of materials : Zinc (which arrived with Haussmann during the 19th century), slate and tile. From the escalator on the outside of the Pompidou Center, the city looks like a colorful mosaic in which all the French provinces are represented.

The architect Gabriel Le Duc was inspired by St Peter's in Rome to build the baroque dome of Val-de-Grâce in the Latin Quarter.

and Café de Flore, on Boulevard Saint-Germain (intellectuals still favor the Flore). James Joyce frequented Le Fouquet's on the Champs-Elysées. Hemingway and Fitzgerald tossed back drinks at the bar of the Ritz Hotel on Place Vendôme. Around the corner, Harry's Bar on Rue Daunou was another favorite, as were the brasseries along Boulevard du Montparnasse, such as La Coupole. Far from their home countries, foreigners sought friendships in these gathering places and exchanged ideas which eventually found their way into powerful works. A stroller in Montmartre, Montparnasse or the Rive Gauche is surrounded by ghosts of the writers, artists and philosophers of the last two centuries. Individual Parisian landmarks have inspired an almost infinite number of works such as *The Hunchback of Notre Dame* by Victor Hugo, and *Phantom of the Opera* originally written in 1911 by the little-known novelist Gaston Leroux. In the contemporary series of children's books featuring the spunky French girl Madeline, the streets of Paris are her playground.

A Permanent Film Set

The first film ever made was screened in Paris in December 1895 by its inventors, the French Lumière brothers, and the French nation has been redefining the art ever since, with Paris as its muse. In the late 1950s, French New Wave cinema was born in Paris with a loose, non-conventional style that forced filmmakers to reexamine the significance of the medium and to use it as a form of self-expression. Jean-Luc Godard's first feature, *A bout de souffle* ("Breathless") was among the earliest of the genre in 1960. Starring Jean-Paul Belmondo and American actress Jean Seberg as the aspiring journalist who hawks the then *New York Herald Tribune* on the Champs-Elysées, it uses Paris as its set. Others did as well: Wim Wenders' *The American Friend*, Louis Malle's *Zazie dans le Métro*, Marcel Carné's *Les Enfants du Paradis*, Jean Renoir's *Boudu Sauvé des Eaux*, and *French Can-can* are all imbued with their makers' reverence for the city.

The Hollywood picture of Paris may have taken mythology to extremes – no bohemian existence could have been as much fun as that witnessed by Gene Kelly's character in *An American in Paris* (1950); prostitution could never have been as glamorous as the world of Gigi in the 1958 film of Colette's story, even in the heady days of the *belle époque*.

But the version of Paris created by the big film studios for an international audience was sufficiently in tune with real experience to help shape the world's mental image of the city, abetted by the songwriters, with "April in Paris", "I Love Paris", "Last Time I Saw Paris", all testimony to the hold of Paris over the American imagination.

If filmmakers have always loved Paris, Parisians also love film. The city has hundreds of screens; going to the cinema is not just a pleasure, it is a national pastime. While Paris, like other cities, has seen most of its cinemas carved up into multiplexes, there are still more than a handful of *grandes salles*, especially on the Champs-Elysées. On Friday and Saturday nights, the plush velour seats in these spacious theaters sell out during the first weeks of a popular new film. At any time of the year, cinema buffs can find a selection of current films not only from France but from countries all over the world, usually in their original language, with French subtitles.

Past Lives

A stroller in the cemeteries of Paris can read the headstones as a "who's who" of the arts and sciences. In the alleys of Père-Lachaise, the largest of the three major cemeteries, one can visit the graves of some of the great French writers and artists including Molière, Apollinaire, Proust, Balzac, Seurat, Pissarro and Delacroix. Prominent foreigners are also buried here, Frédéric Chopin, Oscar Wilde, Gertrude Stein, Alice B. Toklas and Maria Callas among them. A particularly famous grave is that of Jim Morrison, lead singer for The Doors, who died of a drug overdose in a Marais apartment building. His gravesite is usually surrounded by a few fans and is covered with cigarette butts offered by visitors as a tribute. Many graves have their own personality, including the mass grave for the Communard insurgents executed after an all-night battle in the cemetery.

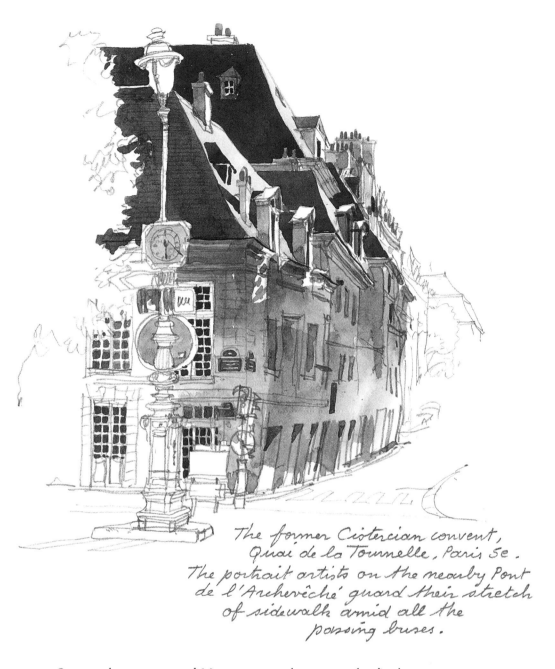

The former Cistercian convent, Quai de la Tournelle, Paris 5e. The portrait artists on the nearby Pont de l'Archevêché guard their stretch of sidewalk amid all the passing buses.

Over at the cemetery of Montparnasse, known as the final resting place for Paris's intellectuals, the French have their own modern music legend – Serge Gainsbourg. In the north corner are the writers Simone de Beauvoir, Jean-Paul Sartre and Charles Baudelaire. Opened in 1824, the cemetery at Montparnasse is

Introduction 15

also the final resting place for the Irish author Samuel Beckett, the French writer Guy de Maupassant, the Romanian sculptor Constantin Brancusi, the American photographer Man Ray, the industrialist André Citröen and the actress Jean Seberg.

Established in 1798, the cemetery at Montmartre is the city's second most famous graveyard. Up on the hill, not far from Pigalle and the basilica of the Sacred Heart, lie the novelist Stendhal, the painter Edgar Degas, the composer Hector Berlioz, the film director François Truffaut, the German poet Heinrich Heine, and the dancer Vaslav Nijinsky.

Changing Faces

France has long embraced the positive influence of foreign intellectuals and artists but it also guards its heritage with a ferocious pride. When English terms such as "weekend," "blue jean" and "le Big Mac" began creeping into local conversation, the Académie Française, charged with protecting the purity of the French language, leapt in to create French alternatives, much to the amusement of many observers. Once the language of diplomacy until World War I, French has largely been replaced by English in this arena, although some 122 million people

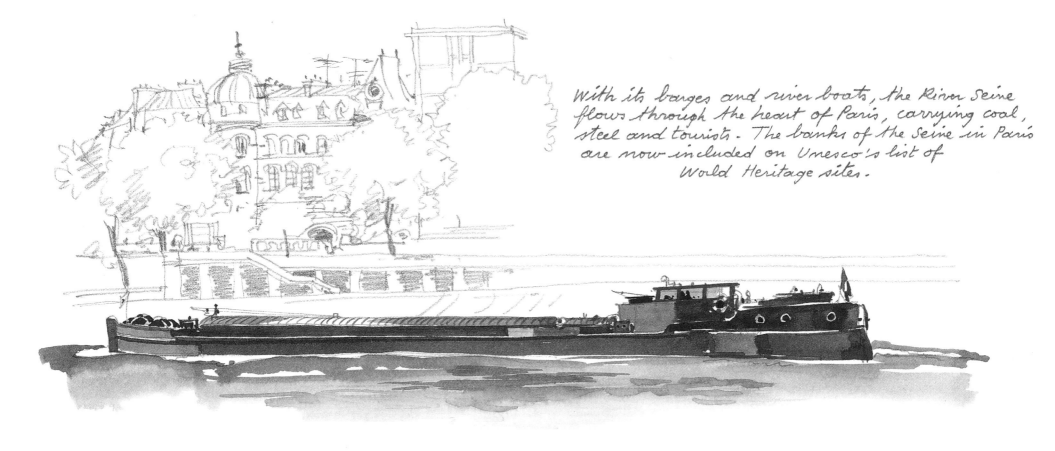

With its barges and river boats, the River Seine flows through the heart of Paris, carrying coal, steel and tourists. The banks of the Seine in Paris are now included on Unesco's list of World Heritage sites.

around the world speak French as their first language. Globalization threatens to make further inroads. English is the language of international commerce and by 2002 the French currency will disappear in favor of the euro. With the increasing homogenization of cultures around the world, national self-preservation efforts are understandable and even welcomed by Francophiles of all countries, but that does not mean there is not a lot of debate. It is little wonder that France has become so sensitive to issues of immigration and language.

About 80 percent of French people are Roman Catholic, but Islam and Judaism are increasingly well represented alongside the capital's many churches. The North Africans who arrived in considerable numbers during the 1950s and 1960s have made Islam the second largest religion in France with mosques springing up in various quarters of Paris. Among them, the biggest is the Mosquée de Paris in the 5th arrondissement with its graceful minaret, tea garden and hammam (bathhouse). Other hammams are scattered around the city and, inside, the bathing rituals are enjoyed by residents of all faiths.

The Marais, on the Right Bank, is also known as the Jewish Quarter; the narrow winding streets and the bakeries of the Ashkenazi and Sephardi Jews have helped make it one of the most colorful places for a stroll. Shops here are open on Sundays, unlike those in other areas of the city which close in observance of the Catholic day of prayer. Immigration of Jews from Morocco, Tunisia and Algeria in the 1960s has swelled the Jewish community in France to the largest in Europe with a popular synagogue on Rue de la Victoire.

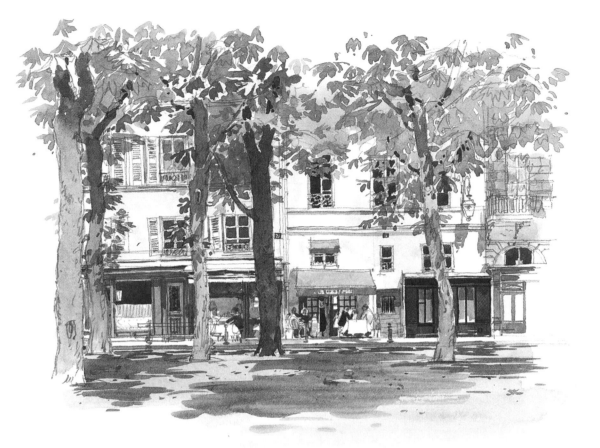

Place Dauphine, located on the Ile de la Cité, is the historical and geographical center of Paris. The city's 20 arrondissements are arranged with this triangular area as their point of origin, spiraling out from it like the shell of a snail.

Elsewhere in Paris, the Chinese, Africans, Indians, Arabs, Latins and other Europeans have opened shops, markets and restaurants making the city a rich combination of internationally diverse communities.

Government-sponsored projects such as the Institut du Monde Arabe, launched to bridge French and Arab cultures, encourage intercultural cooperation while bringing in top art exhibitions, films and musical performers from partner countries. In the case of the Institut du Monde Arabe, Parisians also gained a much-admired building for their city.

The Pantheon was commissioned as an abbey church, but later became a mausoleum for "grands hommes" in French history such as Voltaire and Victor Hugo. The first woman to be buried here was Marie Curie.

A City Renewed

Many cities of the Old World grew from a central walled city (such as Paris once was) and spread out, but none is as beautiful, as visually well-organized or as dense with historic buildings as Paris. How did this happen? This city, which now measures approximately 9.5 kilometers from north to south and 11 kilometers from west to east, has survived two World Wars and numerous battles without suffering much damage. It has also benefited from a series of rulers, past and present, who championed ambitious urban improvement projects. Richelieu, Voltaire and Napoléon were all great promoters of long views, central clearings and squares designed so that building façades could be seen to their greatest advantage. Baron Haussmann, a public administrator under the Emperor Napoléon III, was notoriously ruthless. Between 1853 and 1870, he laid out the broad, straight avenues that remain the city's main arteries today, and some of its loveliest parks, sacrificing many smaller streets and old buildings in the process. Later,

20th-century presidents sought to immortalize themselves with huge public buildings. Such *grands projets* include Georges Pompidou's Pompidou Center, Giscard d'Estaing's Musée d'Orsay and La Villette, and François Mitterrand's Bibliothèque Nationale, glass pyramid at the Louvre, Grande Arche de la Defense, Institut du Monde Arabe and Opéra Bastille. Parisians may have snickered and complained, but most of them – as well as huge numbers of visitors from abroad – agree that the combined effect on their cityscape has been a success overall.

Although Paris is steeped in history and tradition, the city also has a vibrant modern side that gives it an exciting edge. In the realms of art, architecture, dance, design, fashion, food, music, nightlife and more, Paris is an undisputed leader, inspiring people all over the world with new ideas. As each of the modern new structures of the *grands projets* elbowed its way in among the historic buildings in various arrondissements, for instance, the architectural designs sparked controversy, stirred international debate and in most cases earned acclaim. The city has demonstrated innovative ways to recycle architecture: at the Musée d'Orsay, a derelict train station has become a museum; at La Villette, former slaughterhouses have become a state-of-the-art science and technology museum, and the Cité de la Musique. In art, dance, theater and music, the new and the different are not only encouraged, but prized.

It's no wonder, given the impact of artistic movements born in Paris such as Impressionism, Cubism and Surrealism, which were shocking in their day but then revolutionized the arts. The avant-garde is continuously challenging the classical, giving the

contemporary arts scene an exhilarating air of tension. Live performances can be found in hundreds of venues throughout the city. Experimental and avant-garde dance thrives at the lavish Opéra Garnier (where the Ballet de l'Opéra de Paris, the city's own troupe, also has its home), and at the Pompidou Center as well as several more low-key stages in the Bastille. Meanwhile, the most famous international dance companies perform at the Théâtre de la Ville and at the Opéra Garnier.

There are no less than 150 theaters in and around Paris and while the city may be eclipsed by the work that comes out of New York and London, it has made some important contributions to the international theater scene in recent years. The French actress/playwright Yasmina Reza has become the most exported playwright in the world with works translated into more than 35 languages. Her biggest hit, *Art*, premiered in Paris in 1994 and went on to conquer Broadway and the West End.

On the music front, Paris has seen a creative explosion, most notably in North African *râi*, hip-hop and French rap. The city's diverse ethnic community has also helped make it a capital of world music. Here, the sounds of Latin America, North Africa, black Africa and the Middle East combine in new and intriguing ways to the delight of hip nightclubbers and music aficionados from around the globe. A variety of performance spaces and clubs in Montmartre, the Strasbourg-Saint-Denis area and Oberkampf rock with some of the most creative world music programs in town, and are excellent places to dip into the Latin music and dance craze that has swept the city in the last several years. At dance studios and health clubs all over town, such

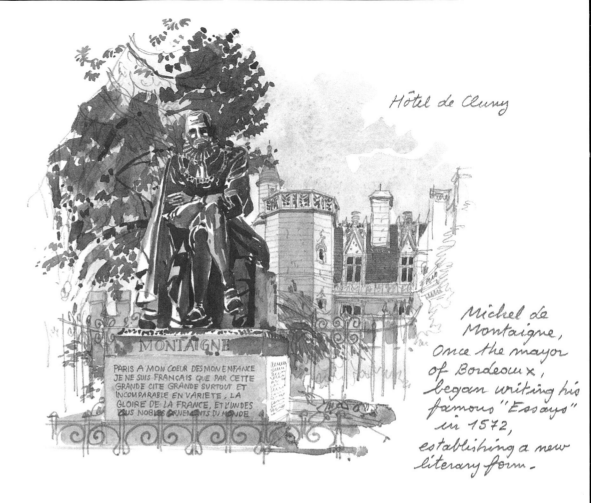

Hôtel de Cluny

Michel de Montaigne, once the mayor of Bordeaux, began writing his famous "Essays" in 1572, establishing a new literary form.

influences have also crept into mainstream course offerings that now include everything from Middle Eastern belly dancing to salsa and hip-hop. Meanwhile, more traditional forms of dance and music also thrive. At various times during the year one can flip on the local television channel and watch intensively competitive ballroom dancing tournaments where couples waltz, tango and rumba.

Naturally, such multicultural flavors have also found their way into Parisian cuisine. But with some notable exceptions, French chefs have stuck firmly to their classical roots, choosing to break ground in other ways. In the 1970s Paris gave birth to nouvelle cuisine, which influenced menus throughout the world

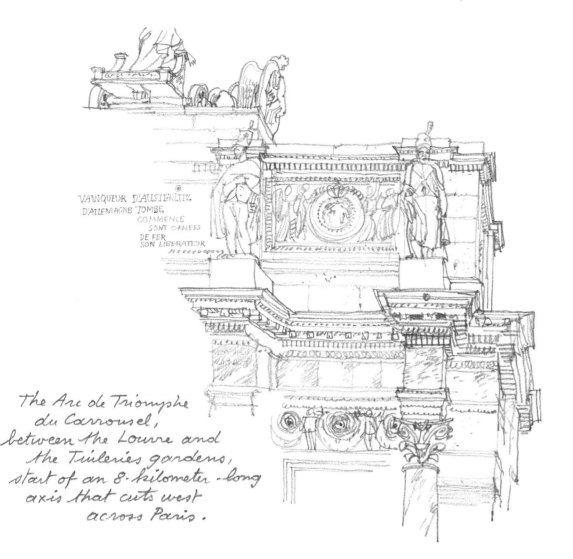

VAINQUEUR D'AUSTERLITZ
D'ALLEMAGNE TOMBE,
COMMENCE
SONT ORNÉS
DE FER
SON LIBÉRATEUR

The Arc de Triomphe
du Carrousel,
between the Louvre and
the Tuileries gardens,
start of an 8-kilometer-long
axis that cuts west
across Paris.

may only be some 2,000 haute-couture clients left in the world, but it seems everyone wants to know what's new, outrageous or simply gorgeous at Chanel, Christian Dior, Christian Lacroix, Balmain, Givenchy and others. Hemlines and shapes make front page headlines and the nightly news as the entire world looks to Paris as the ultimate arbiter of sophisticated taste. The legendary designer Coco Chanel once said : "While fashions pass away, style lives on." Thankfully, as the centuries have passed by, Paris has lived on, preserving its historic character and traditions, while reinventing and improving itself every step of the way.

Today the allure of Paris and the rest of France is at an all-time high and growing. In the year 2000, the country with a population of 58 million welcomed a total of 75 million foreign visitors, a new record. France has become the number one tourist destination in the world. While neighboring countries such as Great Britain struggle with troubled rail transportation systems, French technology has produced and maintained an efficient national railroad with links all over the country including a network of high-speed trains that continues to grow. Long before the Internet, French households and businesses were linked via a national computer network, the Minitel, making it easy to get information and make purchases online.

As France moves forward into the third millennium, Paris remains the ultimate symbol of the country's rich history and independence, its people's passion for beauty and culture and its leadership in a variety of fields from agriculture and technology to gastronomy and fashion. Nowhere is life in the age of high technology lived in a more beautiful setting.

before it happily died. Then there was the start of the "baby" bistro, with some of the city's finest chefs opening smaller establishments with innovative modern cuisine at affordable prices. It was a formula copied from New York to London. Lately, many of the city's most historic restaurants have been updated and improved, to serve an increasingly demanding clientele.

The avant-garde also challenges the classical on Paris's catwalks. Twice a year, in January and July, fashionistas and celebrities from around the world descend on the undisputed capital of haute-couture for the French designers' shows. There

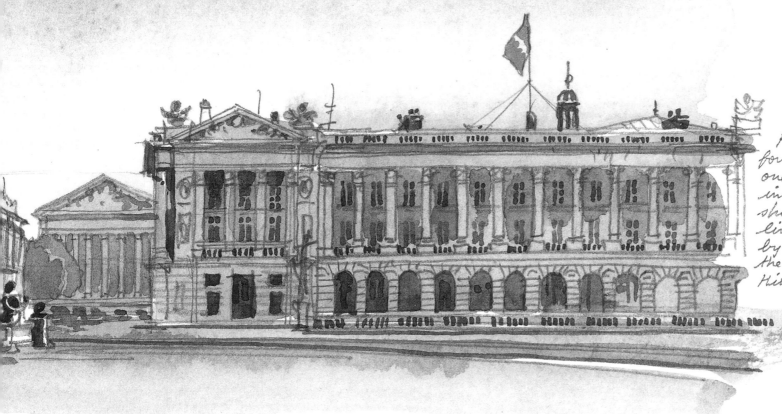

Place de la Concorde, formerly the Place Louis XV, one of the five "royal" squares in Paris. The perfect rectangular shape complements the austere lines of the two palaces designed by Jacques-Ange Gabriel, and the baroque fountains by Hittorff on each side of the obelisk from Luxor.
During the Reign of Terror, Louis XVI, Danton and Robespierre were publicly guillotined here.

south bank. Where the Cathedral of Notre Dame now stands on the eastern end of the island, the Romans worshipped at a temple to Jupiter. Roman remains still exist inside the Crypte Archéologique beneath the square facing Notre Dame.

Paris's medieval history and Gothic architecture are on dazzling display at Notre Dame and the church of Sainte-Chapelle. Climb the narrow spiral staircase in Saint-Chapelle to the upper chapel on a sunny day and the richly colored stained glass windows will take your breath away. On closer inspection, the interior's powerful combination of art and religious devotion only heightens the sense of awe, an unexpected sensation in such a relatively small and often overlooked masterpiece. On

Sunday evenings, a candlelit classical concert in the chapel is a serene ending to a hectic 21st-century working week, especially if followed by dinner at Restaurant Paul in the Place Dauphine.

With its 50 chestnut trees, the leafy square is the most peaceful of the five "royal" squares. From Place Dauphine, Pont Neuf leads to the right bank, affording splendid views of the river and its many bridges. Now is the moment to turn around and look back at the Conciergerie on the island. In the face of its beauty lit up at night, it's hard to believe that this is the infamous prison with such a grisly past, particularly during the Revolution. With heads shaved to the nape of the neck and shirt collars ripped open, prisoners were prepared for death here before being

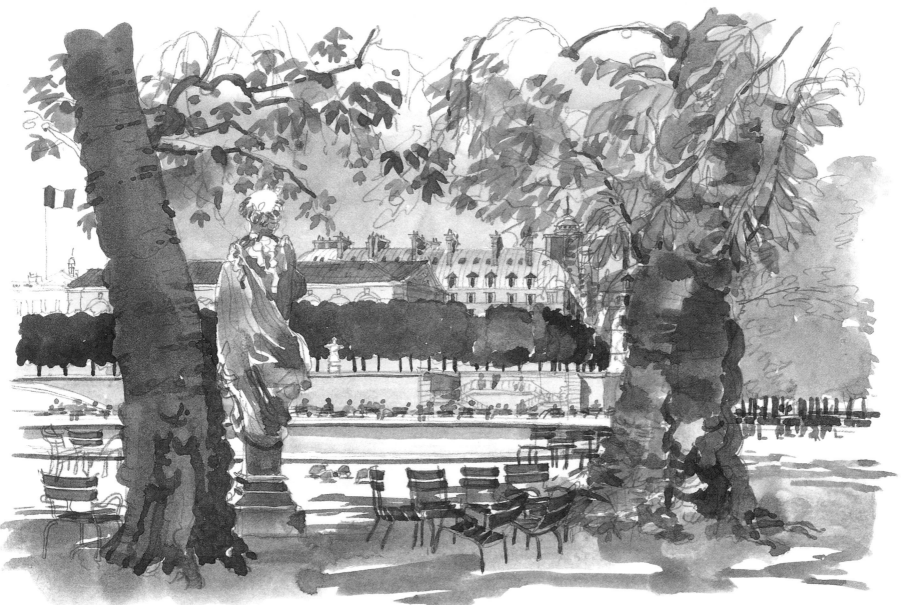

Jardin des Tuileries.
The reflecting pool, the Musée du Jeu de Paume
and, behind it, Rue de Rivoli.

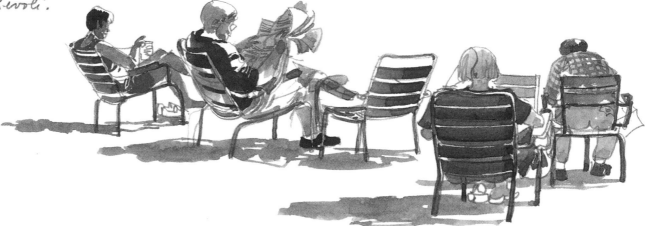

carted over to the guillotine in Place de la Concorde. These days, Place de la Concorde is dominated not by the guillotine's blade, but by an obelisk from ancient Egypt. Transported from its original spot in front of the Temple of Luxor, the precious artifact covered in hieroglyphics recalls the great pharaonic civilizations and attests to France's longtime fascination with Egypt.

On the north side of Place de la Concorde, the elegant Hotel Crillon and the American Embassy add to the square's modern prestige. The Place de la Concorde also sits at the edge of the Tuileries gardens and is a major hub for the Métro.

It is no surprise that the Métro's oldest line, Line 1, opened in 1900, runs directly beneath the most popular above-ground artery of the day, the Voie Triomphale. Early in the morning, runners can have the filtered light and gravel paths of the Tuileries practically to themselves, before the daytime crowds arrive. It is an inspiring experience to sprint beneath Napoléon's small arch at the eastern end to I.M. Pei's glass pyramid shimmering in the empty Cour Napoléon!

On the park's north side, the arcaded Rue de Rivoli leads southeast to Châtelet, the Hotel de Ville and on into the Marais. On the south side, the Assemblée Nationale, the Musée d'Orsay and the Institut de France can be seen across the Seine. Like the ancient Egyptians along the Nile, the early inhabitants of Paris clustered close to their river, their main source of life and livelihood. It is only logical that the densest and most interesting collection of sites should be found in the tight spiral that opens out from the heart of Paris on an island in the first arrondissement, to the 2nd, 3rd and 4th.

Paris is a city where historic grandeur and simple pleasures collide. In the 1660's the great landscape artist André Le Nôtre designed the Tuileries Gardens with a rigid symmetry that attested to Louis XIV's power — even over nature. Today, the formal gardens have become the site of a lively amusement park each summer.

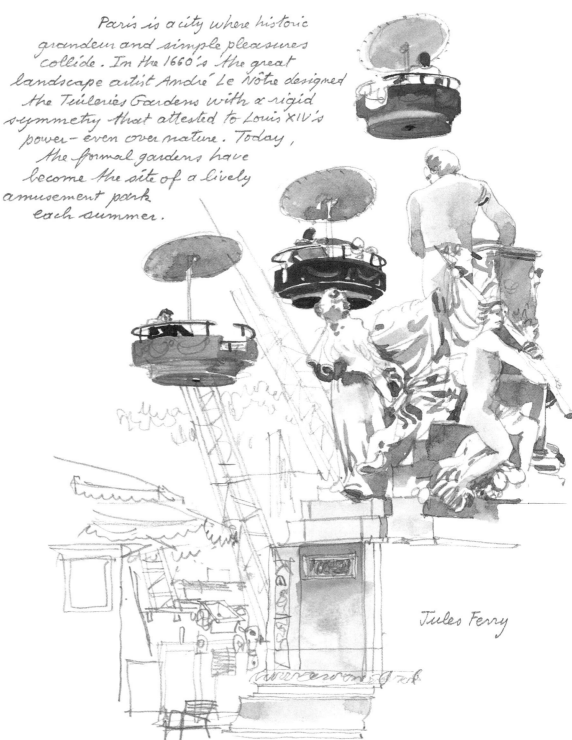

Jules Ferry

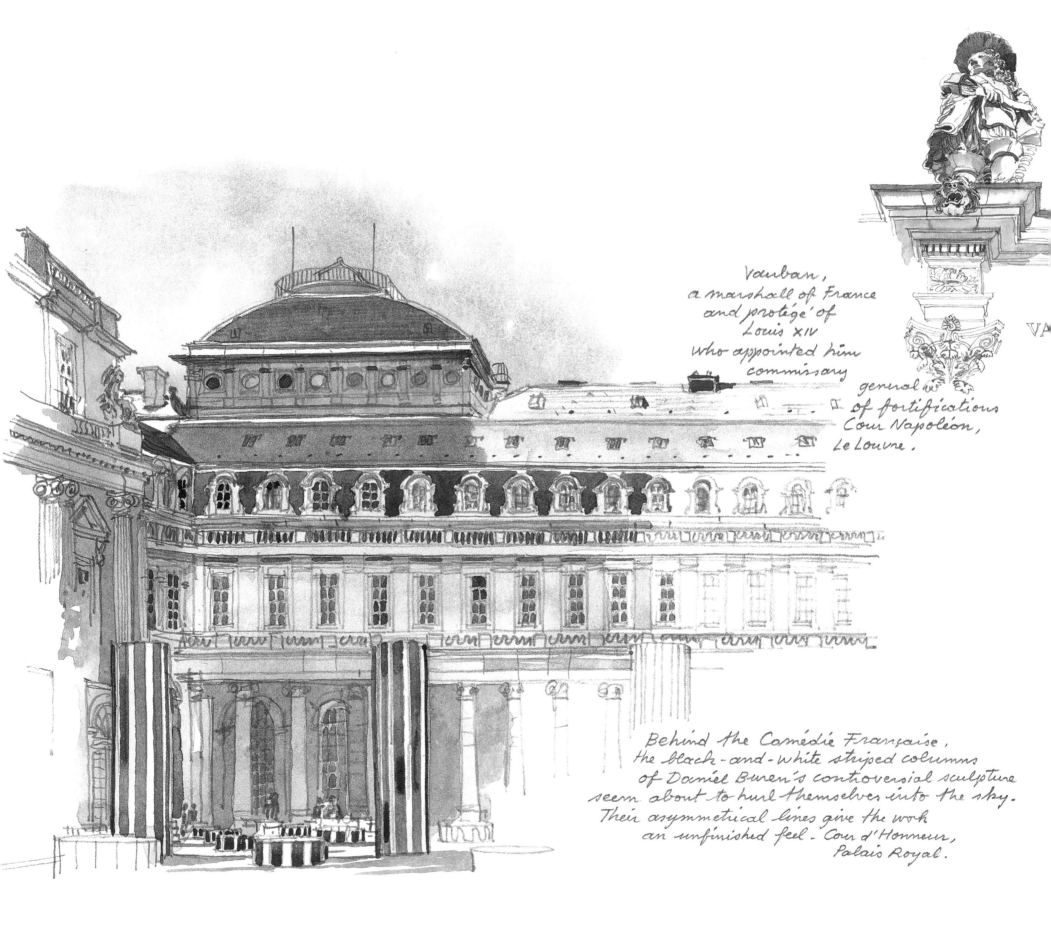

Vauban,
a marshall of France
and protégé of
Louis XIV
who appointed him
commissary
general
of fortifications
Cour Napoléon,
Le Louvre.

VA

Behind the Comédie Française,
the black-and-white striped columns
of Daniel Buren's controversial sculpture
seem about to hurl themselves into the sky.
Their asymmetrical lines give the work
an unfinished feel. Cour d'Honneur,
Palais Royal.

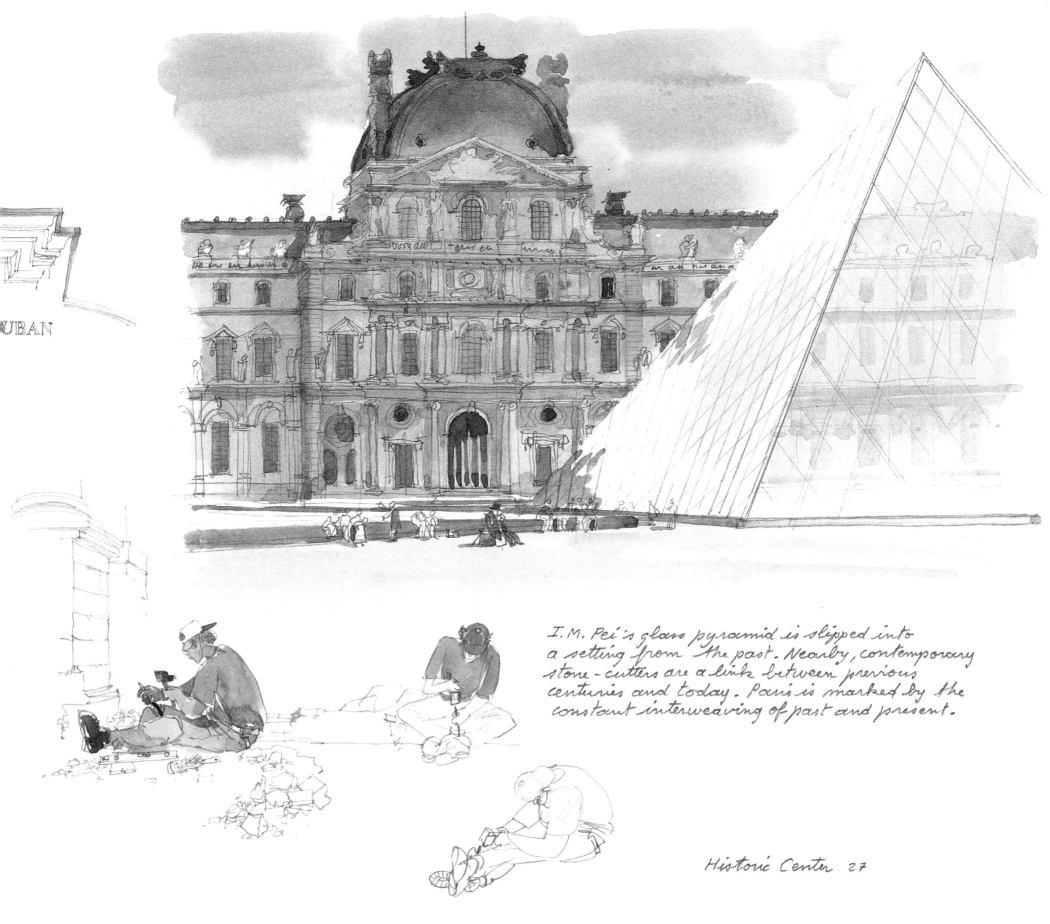

UBAN

I.M. Pei's glass pyramid is slipped into
a setting from the past. Nearby, contemporary
stone-cutters are a link between previous
centuries and today. Paris is marked by the
constant interweaving of past and present.

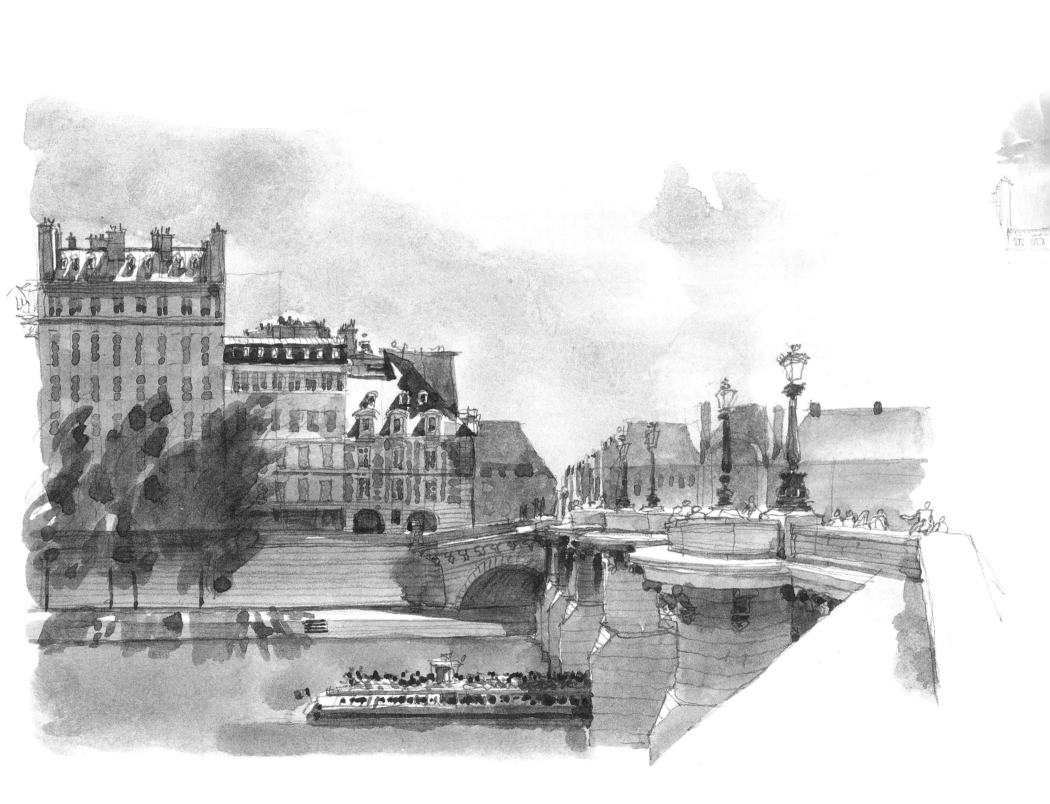

28 Paris sketchbook

Linking the right and left banks of
the Seine are the bridges of Paris,
the oldest of which is the Pont Neuf.
It was inaugurated in 1607 by Henry IV,
who crossed it on a white stallion, an event
commemorated with the capital's first
equestrian statue of a king.
The bridge soon became a favorite gathering
place, where 17th-century street performers
would make crowds of Parisians laugh
so much they wouldn't notice the pickpockets.
In the 18th century, the philosopher,
mathematician and politician Condorcet,
who lived in the Hôtel de la Monnaie
(the former French Mint), crossed the bridge
every morning to visit
his friend
d'Alembert.
In 1990, film stars Juliette
Binoche and Denis Lavant
met there to dance,
love and play in "Les Amants
du Pont Neuf" by Léos Carax.
When Christo wrapped the
venerable bridge in beige
canvas in 1985, Parisians came
from all over the city to stroll
upon it. Like a protective
case, the fabric held up
under the feet of millions
of visitors who came to talk,
look and touch

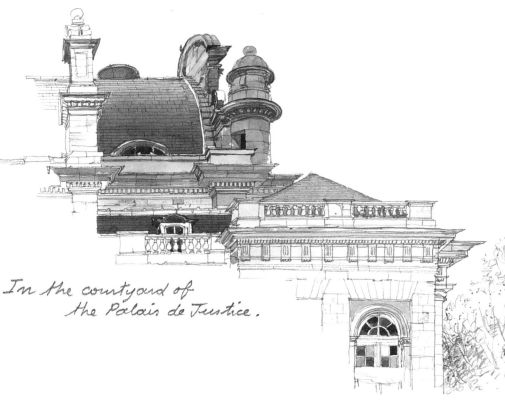

In the courtyard of
the Palais de Justice.

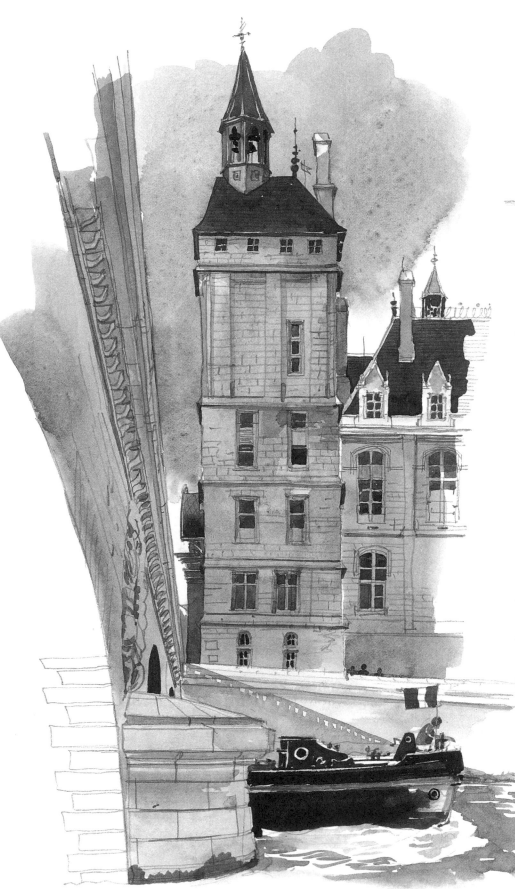

The cathedrals of the Middle Ages were built
using only one material, stone, in order to
show God the unity of the human race.
At the beginning of the 12th century, Gothic
architecture succeeded the Romanesque, and
pointed arches replaced semicircular. So that
God's light would enter the place where one prayed,
it was necessary to invent an architectural
technique that would not require such massive
stonework. Aided by buttresses, including
external flying buttresses, a structure employing
intersecting ribs made it possible to give the
stained glass window the expanse that it
needed to serve as a screen for the first showing,
in color, of liturgical scenes to a large audience.

The Conciergerie,
the Quai de l'Horloge,
and the Pont au Change.

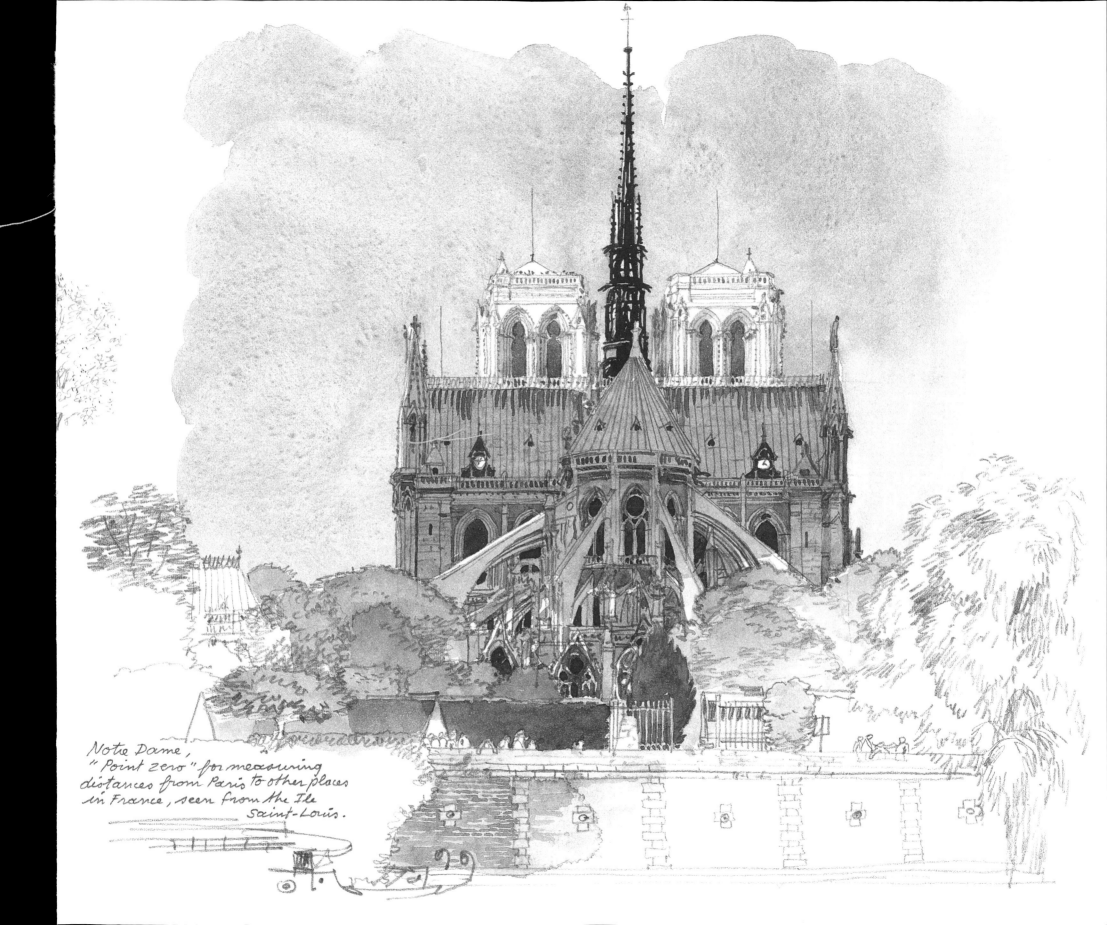

Notre Dame,
"Point zero" for measuring
distances from Paris to other places
in France, seen from the Île
Saint-Louis.

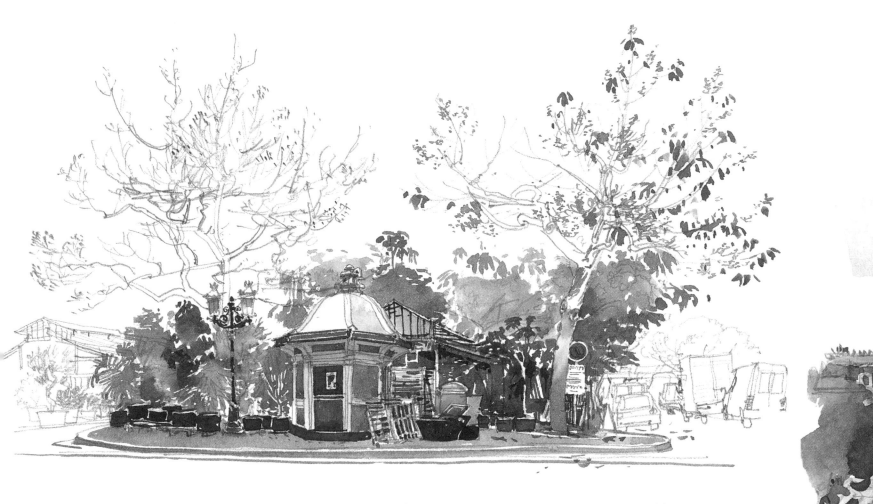

Built on the site of a former Jewish quarter (12th century), the Flower Market, with its nearby Bird Market, is the only place in the capital where strollers can enjoy the song of robins and the scent of mimosa.

Behind Saint-Gervais, narrow winding streets with half-timbered houses give a flavor of the Middle Ages. The Compagnons du Tour de France, the guild of skilled artisans, installed a showcase there, filled with a rich collection of works dedicated to carpentry and masonry.

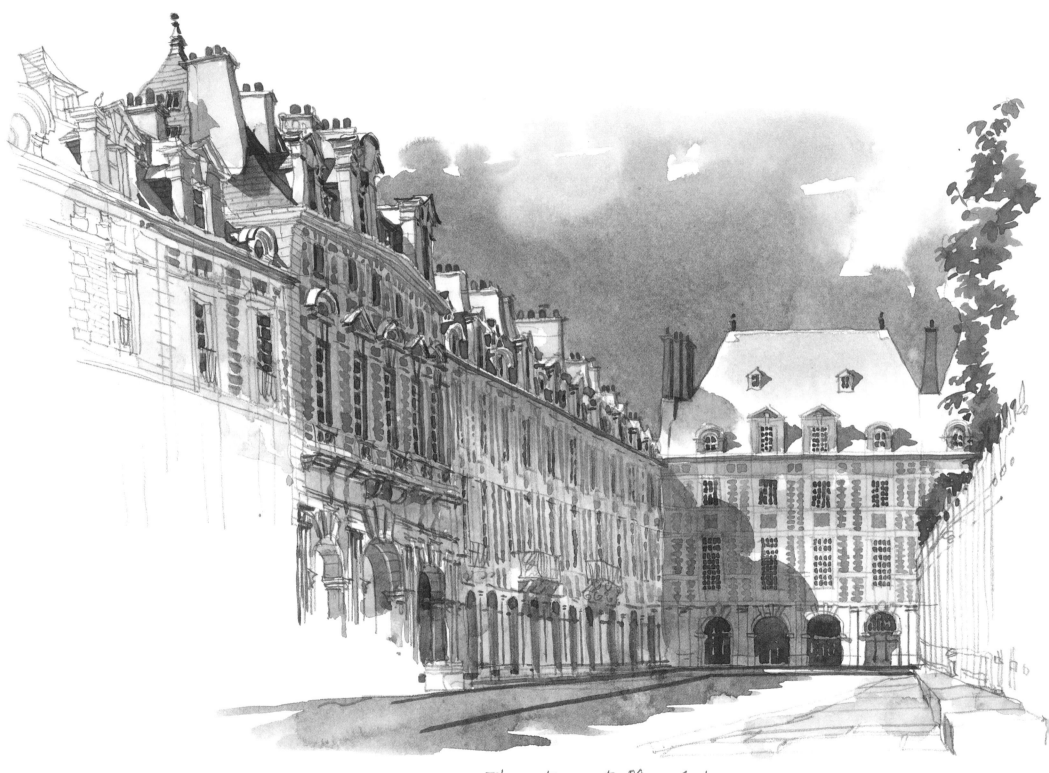

The entrance to Place des Vosges,
one of the five
"Royal" squares.

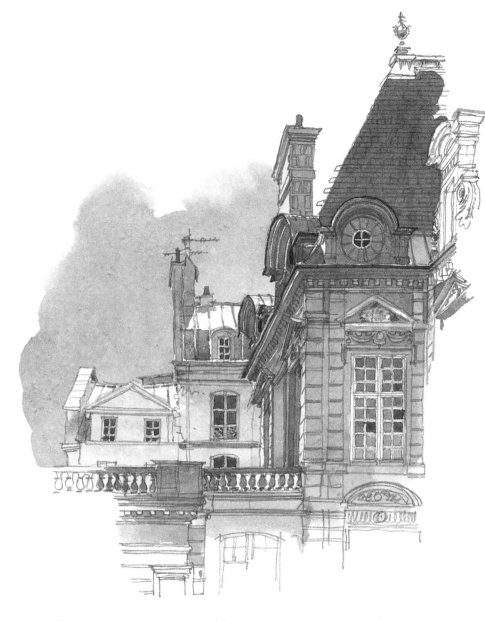

In the Marais, the mansions of Mayenne and Sully are good examples of early - 17th-century architecture. Rue Saint-Antoine, once the most prestigious thoroughfare in the city, was used for formal entrances into the capital. Such an event was the return of Louis XIV and Marie-Thérèse from Saint-Jean-de-Luz on their way to Place Dauphine, where Parisians celebrated their marriage.

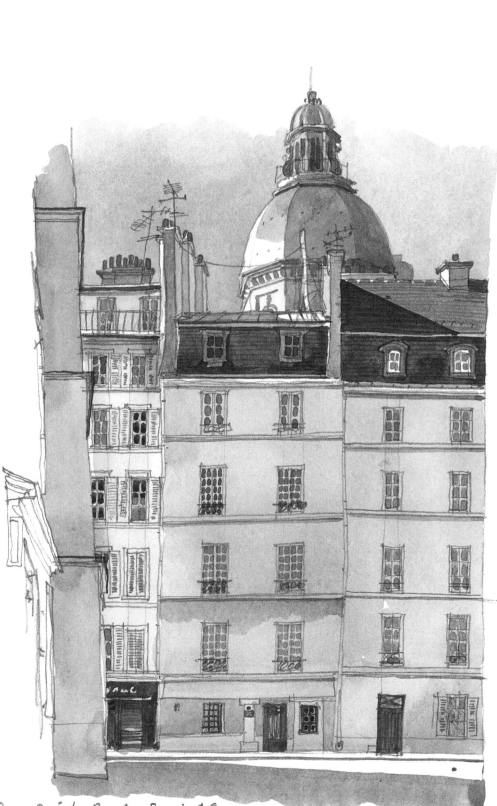

Rue Saint-Paul, Paris 4ᵉ.

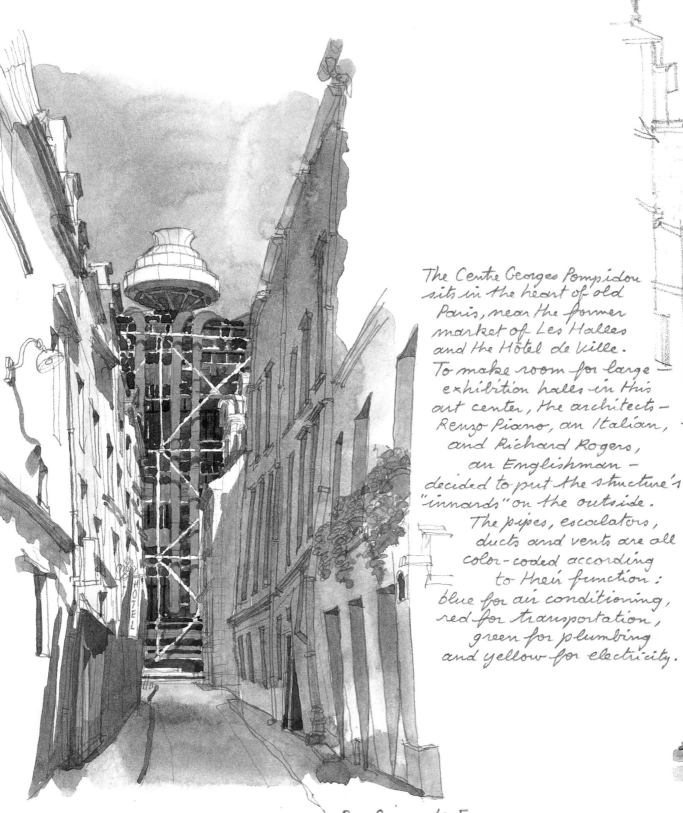

The Centre Georges Pompidou
sits in the heart of old
Paris, near the former
market of Les Halles
and the Hôtel de Ville.
To make room for large
exhibition halls in this
art center, the architects —
Renzo Piano, an Italian,
and Richard Rogers,
an Englishman —
decided to put the structure's
"innards" on the outside.
The pipes, escalators,
ducts and vents are all
color-coded according
to their function:
blue for air conditioning,
red for transportation,
green for plumbing
and yellow for electricity.

Rue Simon Le Franc,
Paris 4e.

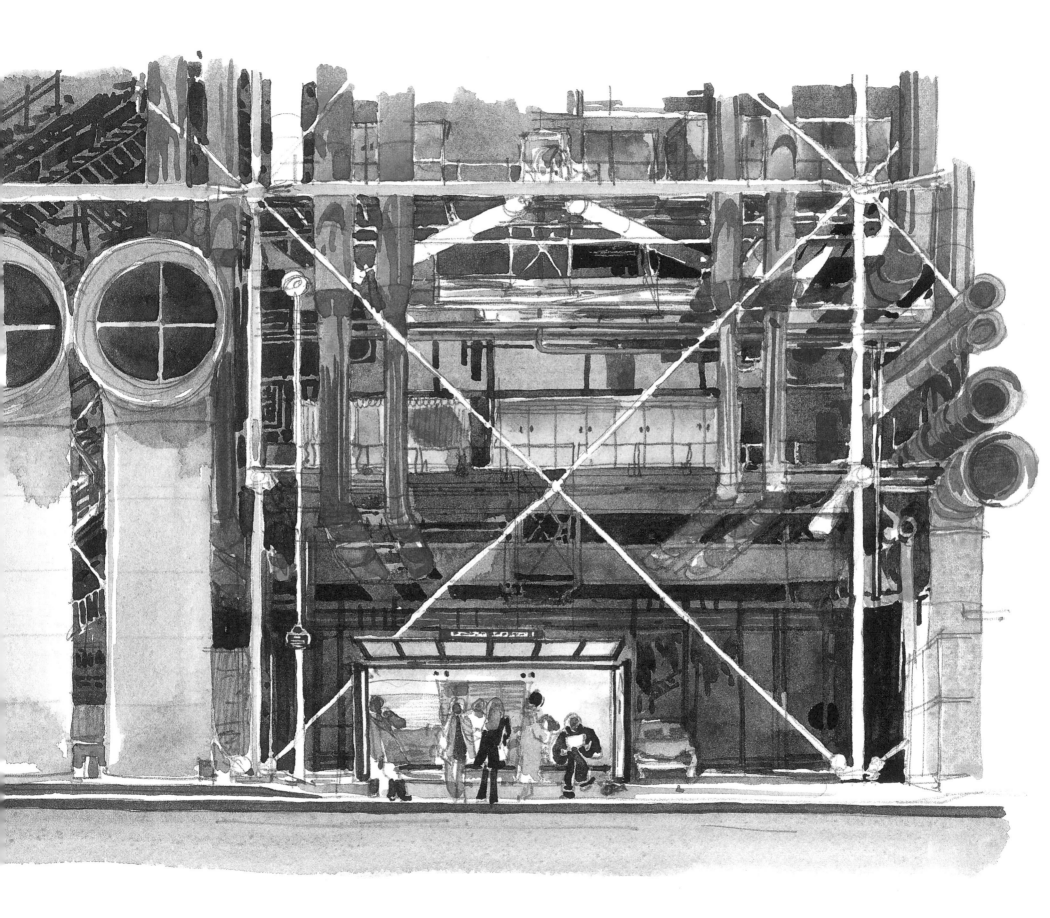

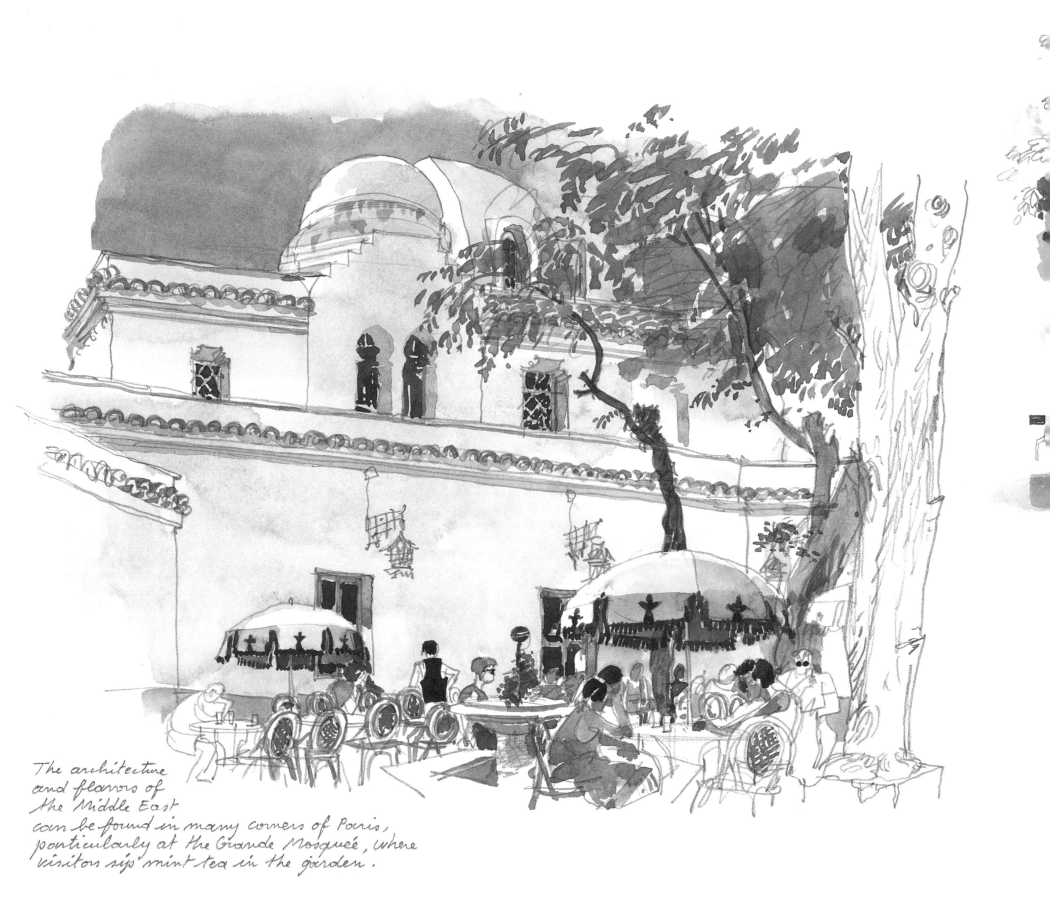

The architecture
and flavors of
the Middle East
can be found in many corners of Paris,
particularly at the Grande Mosquée, where
visitors sip mint tea in the garden.

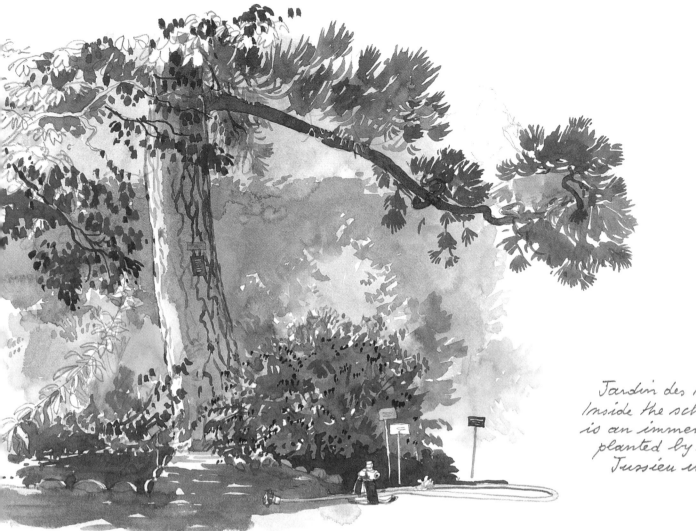

Jardin des Plantes.
Inside the school of botany
is an immense Corsican pine,
planted by the botanist
Jussieu in 1734.

Just east of the Latin Quarter,
the Jardin des Plantes contains two greenhouses,
a rose garden; 400 varieties of iris;
frangipanis; palm trees; a school of botany;
a zoo; and the National Museum
of Natural History. Founded in 1633 by
Louis XIII, the gardens are a lovely place to
walk, to breathe the muggy "tropical air"
and to ponder what life might have
been like 65 million years ago when
dinosaurs roamed the earth.

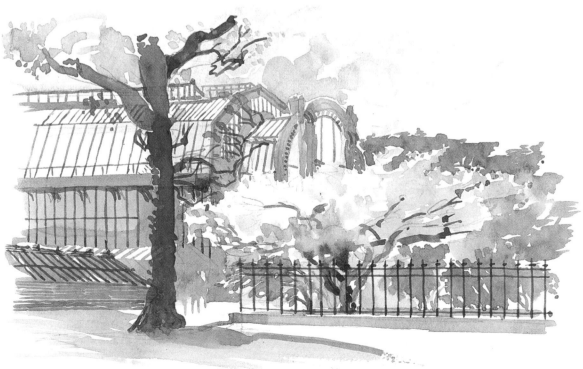

Saint-Etienne-
du-Mont.
a collage of
architectural
styles.

That part of the 5th and 6th arrondissements
between the church of Saint-Etienne-du-Mont,
Rue de la Huchette, Rue Saint-Julien-le-Pauvre
and Thermes de Cluny has seen many
students over the centuries. They are a familiar
sight, hurrying to classes beneath the leaning
walls and wrought-iron lamps,
a sandwich in one hand, a notebook in the
other. Between the Sorbonne and the Seine, Tunisian,
Greek and Turkish restaurants have been
welcoming post-theater diners since the first
performances of Ionesco's "La Cantatrice
Chauve" were staged more than 40 years ago.

Place de la Contrescarpe, leading into
Rue Mouffetard, which tumbles down the hill known
as "La Mouffe" to Eglise Saint-Médard.
Paris 5e.

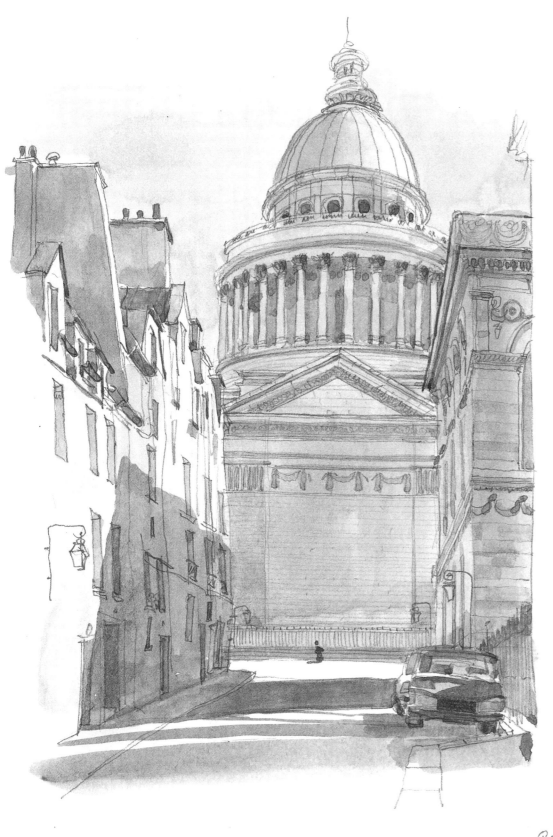

The last "grand homme" to be interred in the Panthéon was André Malraux. This charismatic novelist, art historian and statesman was, especially in his youth, also an advocate of social change. He went to Spain at the outbreak of the Spanish Civil War in 1936 and helped lead the Republican forces against Franco.

At Shakespeare and Co., the beat generation is well represented in the works of Burroughs, Ginsberg, Kerouac, Corso and Ferlinghetti among many other books. Walt Whitman's grandson runs this much loved bookstore.

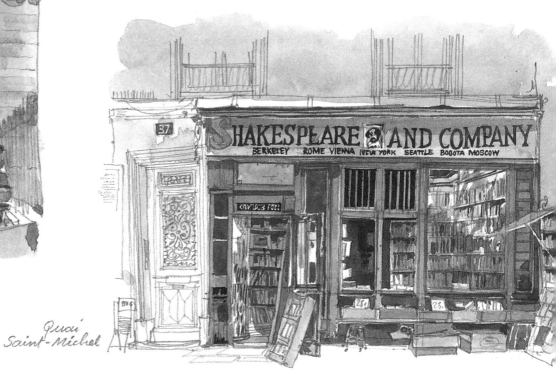

Quai Saint-Michel

The architect Jean Nouvel envisioned
an Institut du Monde Arabe built of
metal and glass, combining Arab and
Western elements in a blend of tradition and modernity.
A mashrebeeyah motif on the southern façade
incorporates mechanisms that open and close like the
iris aperture of a camera lense throughout the day to control
the amount of heat and light entering the building.
One of the best views of Notre Dame's gothic architecture
can be seen from the terrace.

View from Pont Sully

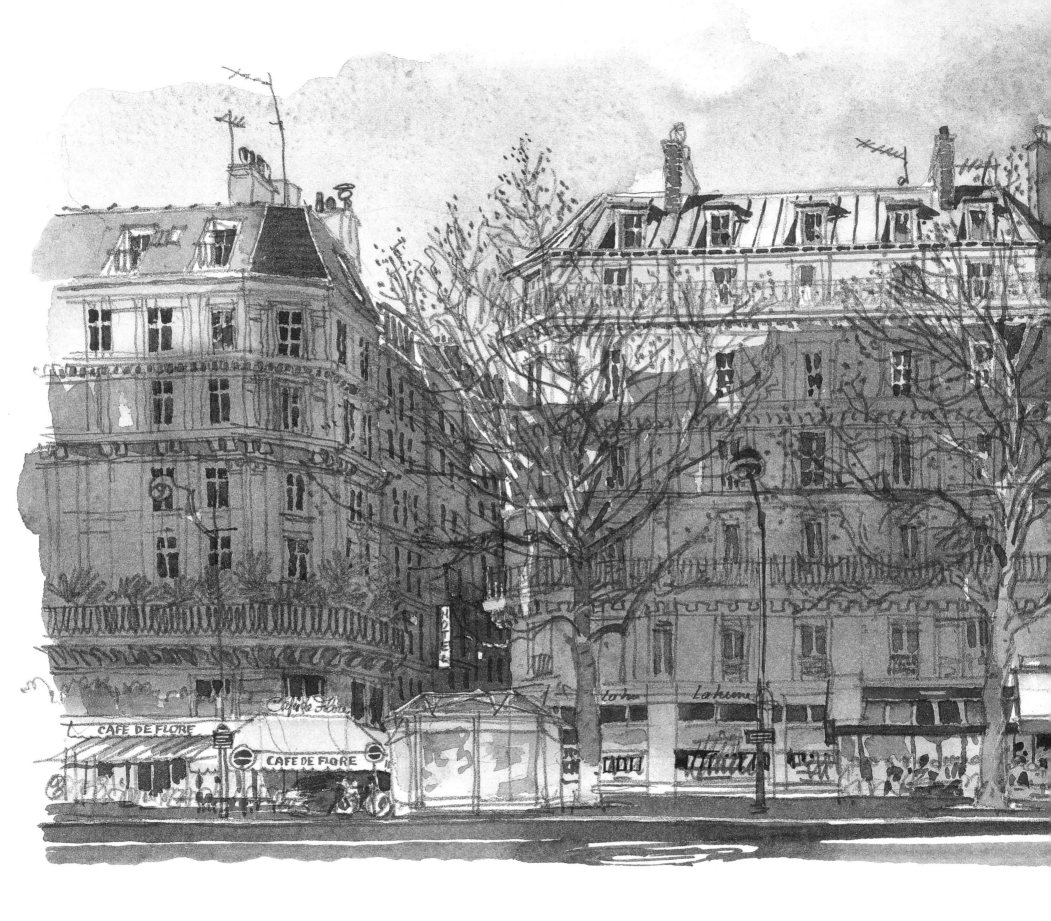

In the 1950s, existentialism was born at the Café de Flore and at Les Deux Magots, popular haunts of the city's many poets, philosophers, musicians and painters. Here, Picasso met Dora Maar, while Simone de Beauvoir and Sartre sipped drinks at a nearby table, just a few steps away from their apartment on the corner of Rue Bonaparte and Place Saint-Germain-des-Prés. The square has recently been rebaptized in their two names.

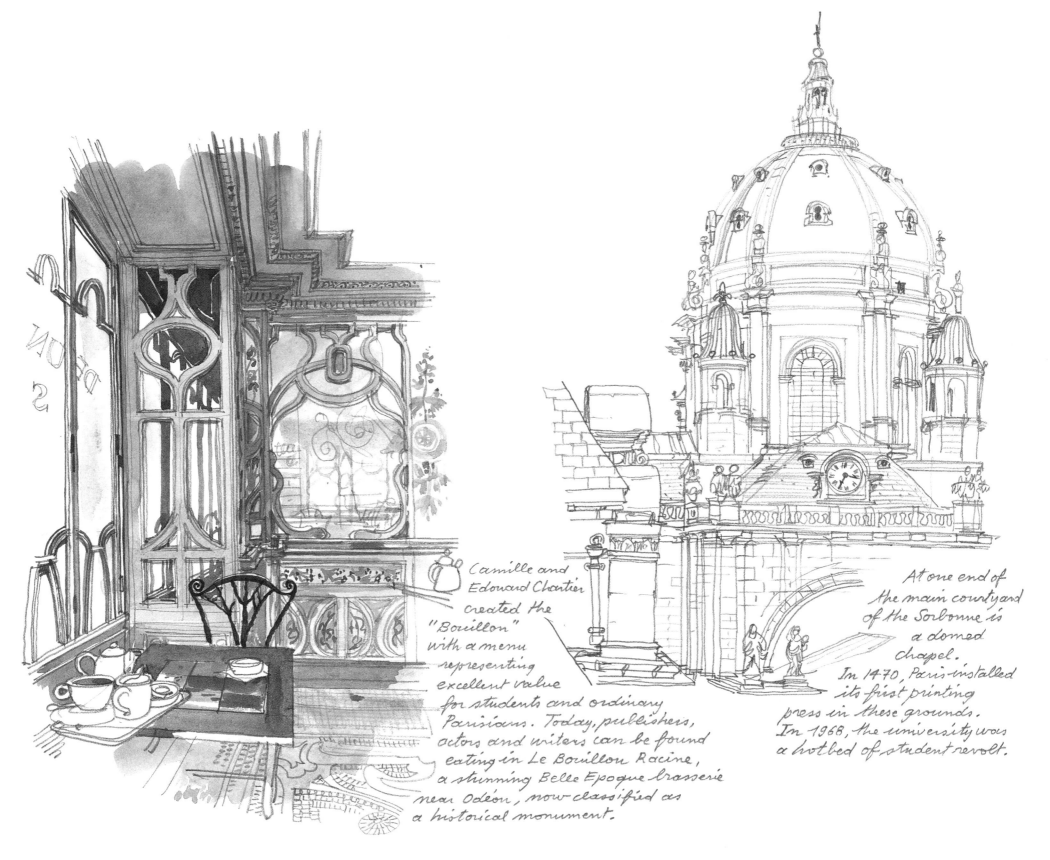

Camille and Edouard Chartier created the "Bouillon" with a menu representing excellent value for students and ordinary Parisians. Today, publishers, actors and writers can be found eating in Le Bouillon Racine, a stunning Belle Epoque brasserie near Odéon, now classified as a historical monument.

At one end of the main courtyard of the Sorbonne is a domed chapel.
In 1470, Paris installed its first printing press in these grounds.
In 1968, the university was a hotbed of student revolt.

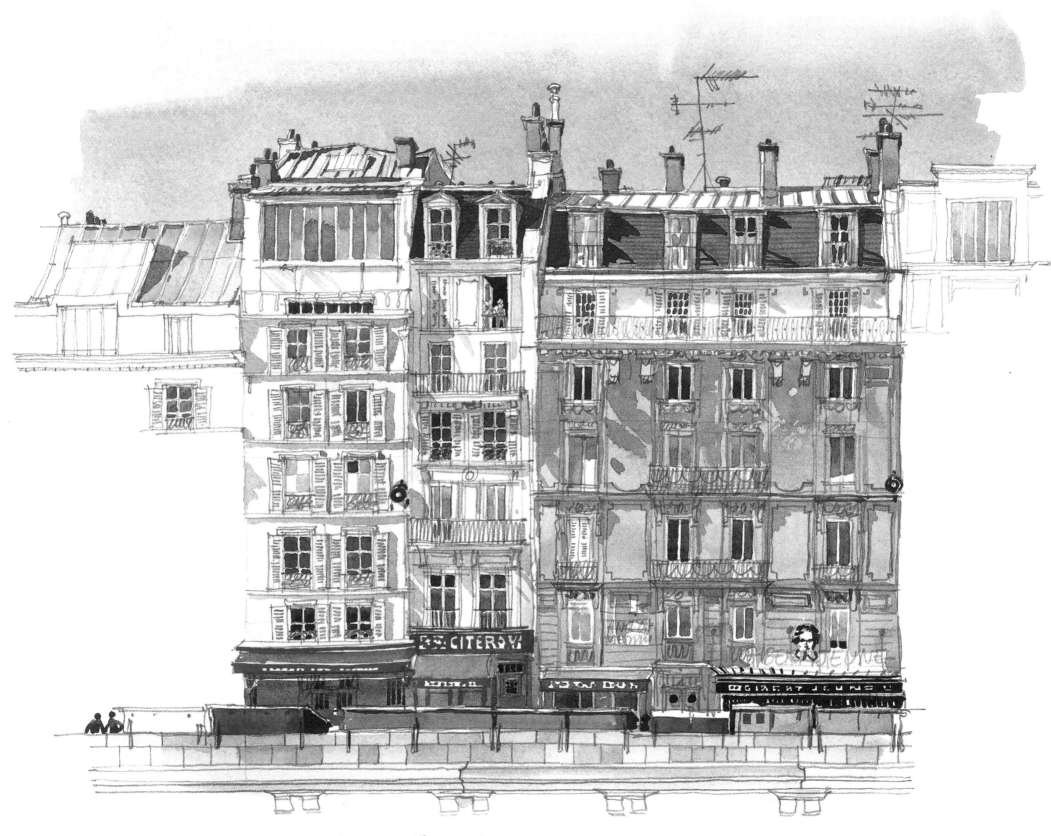

Quai Saint-Michel. Matisse's studio.
Many painters set up ateliers behind the big bay windows on
the north sides of Parisian buildings.

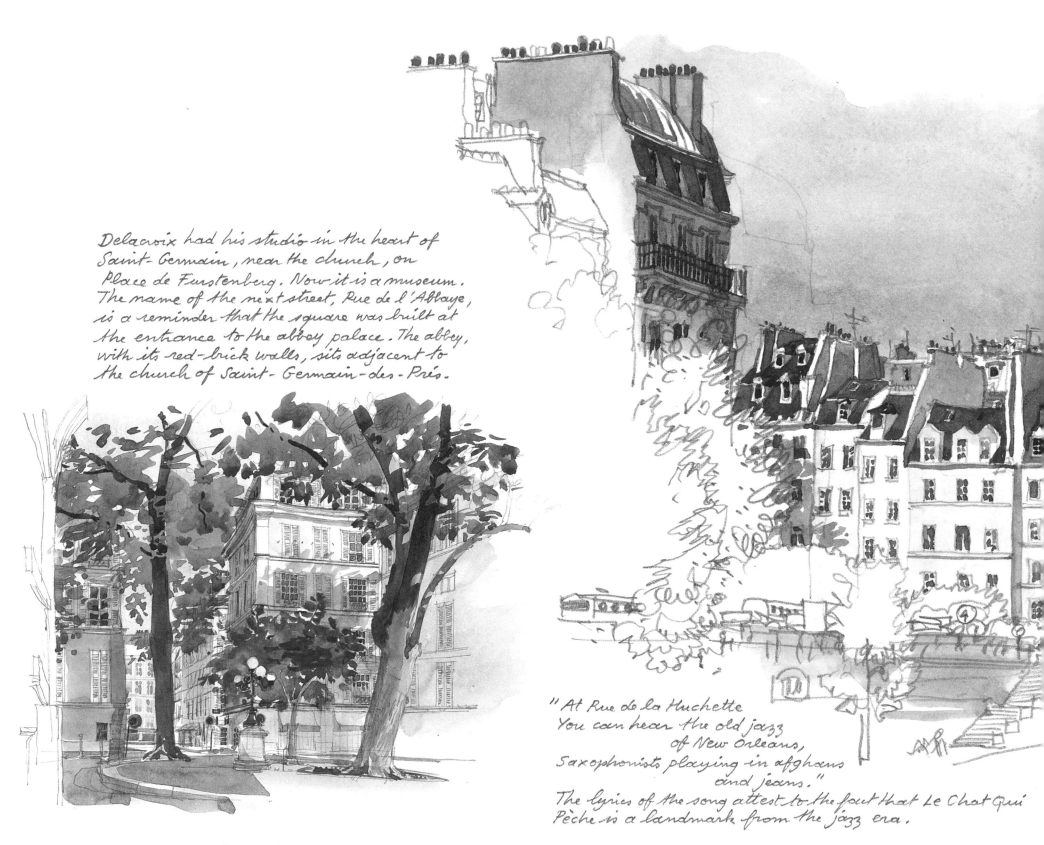

Delacroix had his studio in the heart of
Saint-Germain, near the church, on
Place de Furstenberg. Now it is a museum.
The name of the next street, Rue de l'Abbaye,
is a reminder that the square was built at
the entrance to the abbey palace. The abbey,
with its red-brick walls, sits adjacent to
the church of Saint-Germain-des-Prés.

"At Rue de la Huchette
You can hear the old jazz
 of New Orleans,
Saxophonists playing in afghans
 and jeans."
The lyrics of the song attest to the fact that Le Chat Qui
Pêche is a landmark from the jazz era.

Le Petit Pont.

The 19th-century
novelist
Honoré de Balzac
aspired to be a
publisher and printer
as well as the greatest
storyteller of
his day. He installed
his first printing-press
on Rue Visconti, a small street between
Rue Bonaparte and Rue de Seine.

Next to the Senate is
the Jardin du Luxembourg.
White chestnut, beech and plane trees
cast their shadows over the gently
playing waters
of the Medicis fountain.

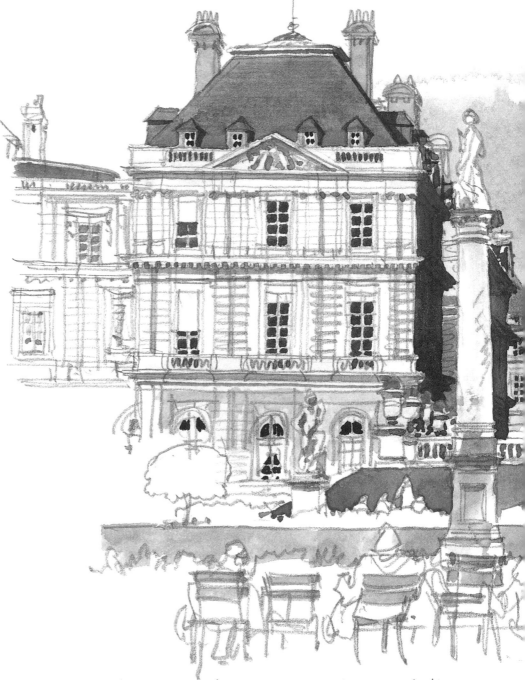

In the Jardin du Luxembourg, people sit, sun-bathe,
think and may even enjoy a romantic dalliance
around the flower beds in the shade of the statues.
Rhododendrons, pomegranate trees and orange trees
are all neatly arranged in planters and bloom ac-
cording to their season. One can also admire two
specimens of Ginkgo biloba donated by an American
president. In the summertime, the inhabitants of
the 20 beehives in the gardens fly around gathering
their nectar and pollen, and the sounds of the fife
and trumpet can be heard when the bands come to
play on Sundays.

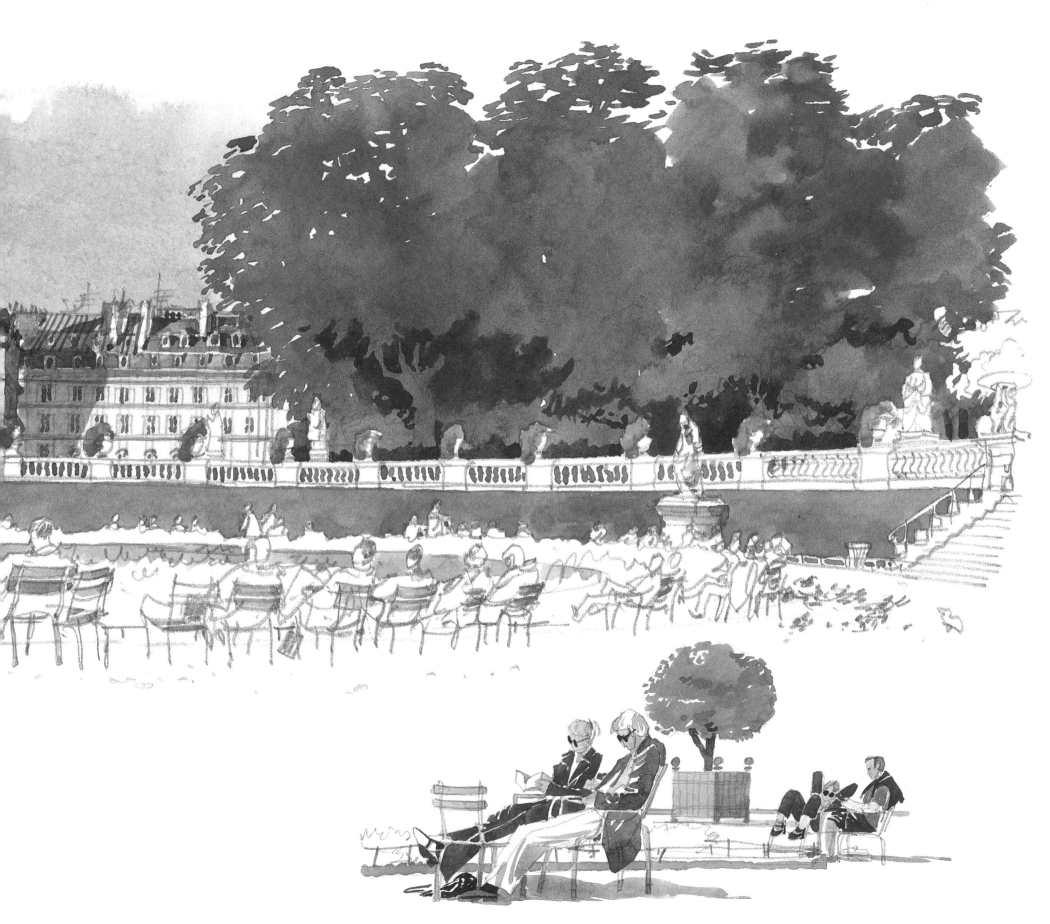

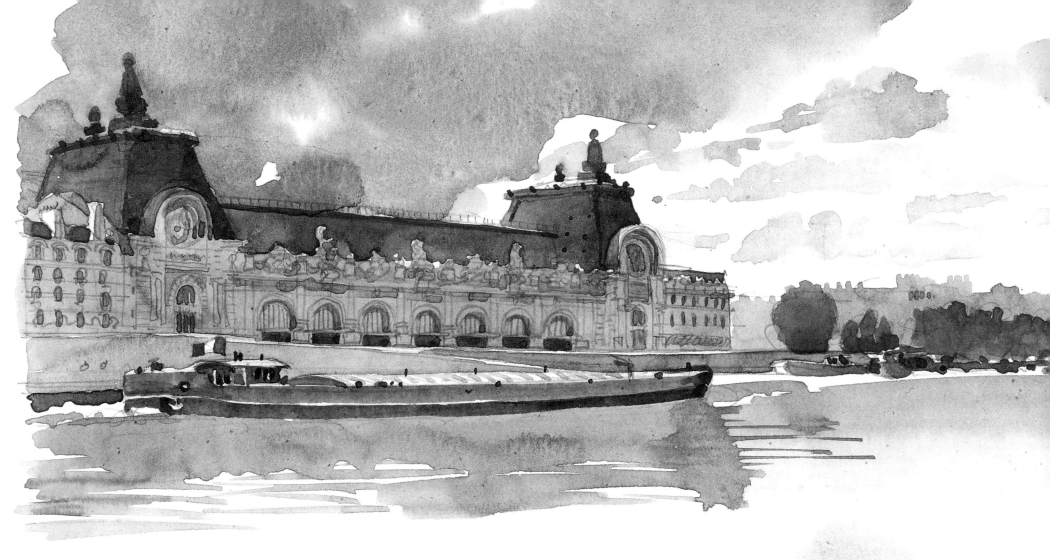

The Musée d'Orsay is a former train station transformed
into a museum.
It was built at the end of the 19th century during the glory
years of rail. The legendary steam engines have been
replaced by the works of Gauguin, Van Gogh and Monet.
There is silence instead of crackling announcements from
the station's loudspeakers; Van Gogh's "L'Eglise
d'Auvers-sur-Oise" is displayed where posters of Arcachon
and its seaside village used to hang. A president from
the political right began the museum project, a president
from the left completed it. Such is the continuity of
the French Republic.

Le pont du Carrousel. Le Louvre.

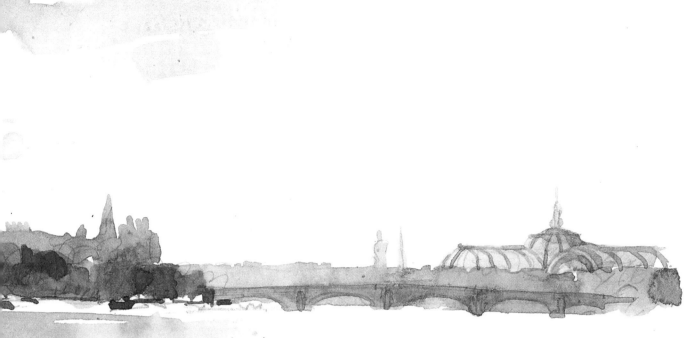

The Musée d'Orsay and, in the distance, the Grand Palais seen from the quai des Tuileries.

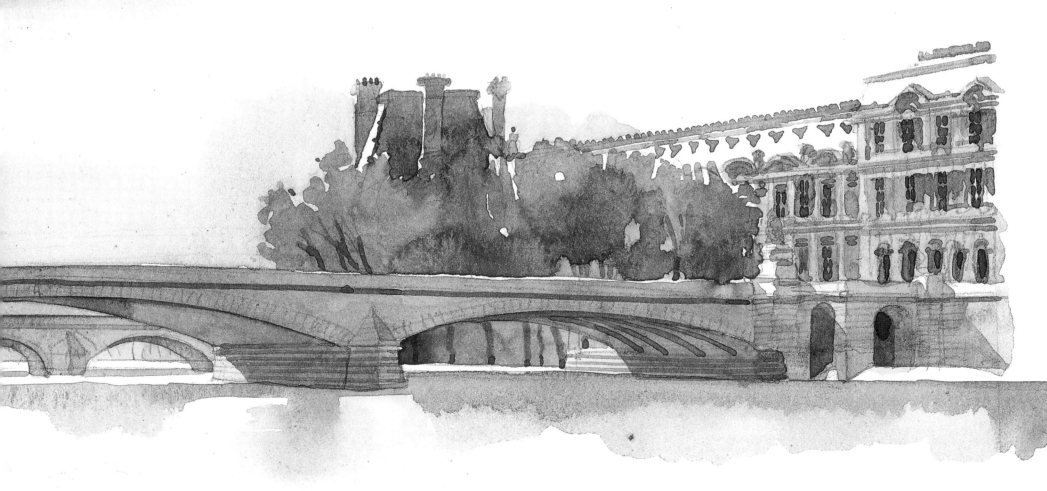

Northern Paris

Conversation, caipirinhas and people-watching: an improvised sidewalk café.

Dominated by the graceful white domes of the Basilique du Sacré Coeur on the top of the hill, northern Paris is perhaps best known for the area of Montmartre in the 18th arrondissement. Once a hilltop village that supplied wine from its vineyards and flour from its windmills, Montmartre evolved into a city neighborhood with cabarets, dance halls, brothels and a thrilling reputation for decadence. In the late 19th century, the atmosphere drew artists, writers, poets and musicians and the area became a bastion of creativity. This was pre-World War I *gai* Paris at its finest. Van Gogh lived at 54 Rue Lepic and found inspiration in the surrounding windmills and gardens. Renoir lived on Allée des Brouillards and immortalized an evening at one of the open-air cabarets in his painting "Bal du Moulin de la Galette." Camille Pissarro lived at 12 Rue de l'Abreuvoir, once a country lane for horses and cattle heading to the watering trough (*abreuvoir*). Today, the cobblestone streets, steep staircases and shops retain much charm. At the bottom of the hill of Montmartre is the red-light district of Pigalle and the notorious Moulin Rouge, where performers have included Edith Piaf and Frank Sinatra.

But northern Paris has other faces. The ornate Opéra Garnier and the Grands Boulevards with their big department stores in the 9th arrondissement. The Gare du Nord, from which highspeed trains whisk travelers to London and Brussels more efficiently than the airlines. The Canal Saint Martin with paths shaded by plane trees – perfect for strolls or bike rides. And la Goutte d'Or, an old working-class area now popular with African immigrants, where the local market is stocked with colorful fabrics.

Rue du Calvaire,
Montmartre.
 The climb up
Butte de Montmartre
may be arduous,
but the view
from Sacré Coeur,
perched at the top,
is sublime.

Musée de
Montmartre,
12 - rue Cortot.
Paris 18e.

Montmartre is for ever associated with the Paris Commune and the
artists who lived and worked there in the late 19th century. Among
them were Louise Michel, revolutionary, poet and teacher; and
Jean - Baptiste Clément, author of "Le Temps des Cerises". Both
were cheered when they returned to Montmartre from exile
in 1880. In Le Bateau-Lavoir, a group of buildings
Max Jacob called "the central laboratory", poets and
painters exchanged ideas and shaped their visions of
the world, before expressing them in their work. Corot,
Braque, Jacob and Apollinaire all lived in these buildings,
demolished in 1970; here, Picasso painted the masterpiece
that launched an artistic revolution at the start of the
20th century: "Les Demoiselles d'Avignon".

Today, sidewalk artists
tempt the passing tourists.
Place du Tertre.

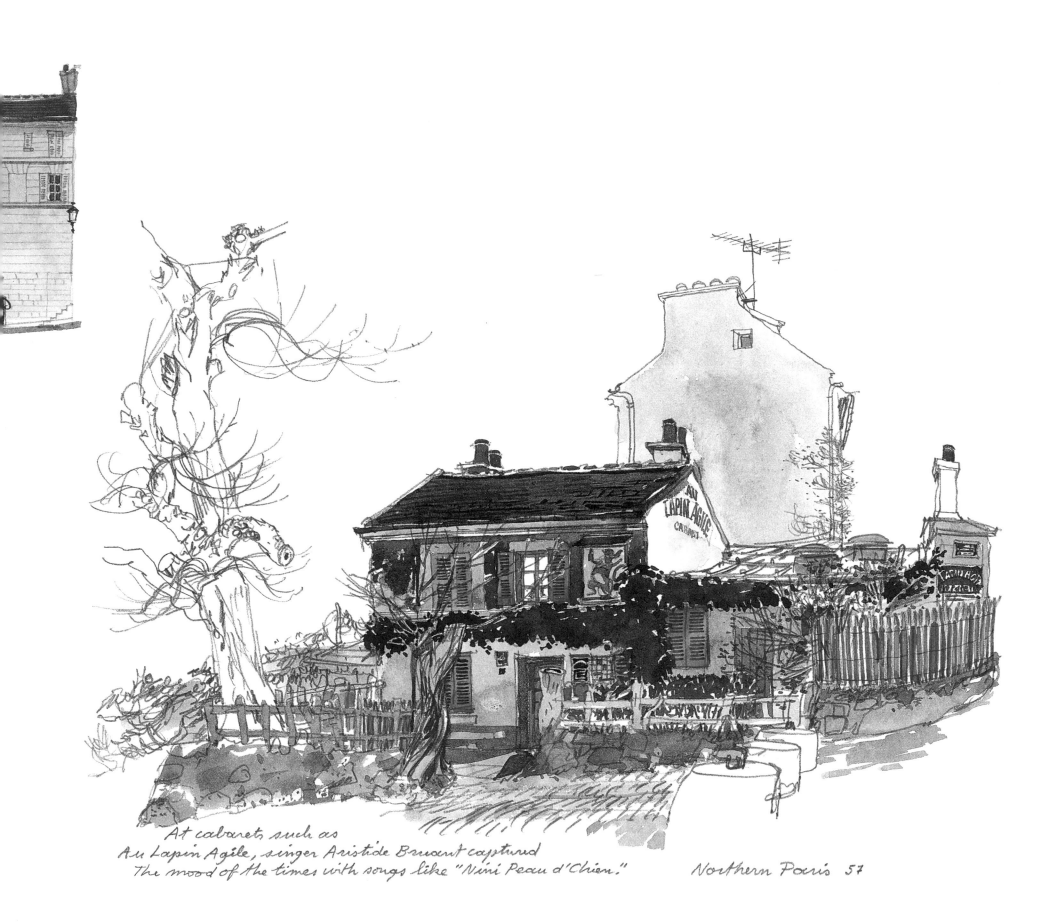

At cabarets such as
Au Lapin Agile, singer Aristide Bruant captured
the mood of the times with songs like "Nini Peau d'Chien." Northern Paris 57

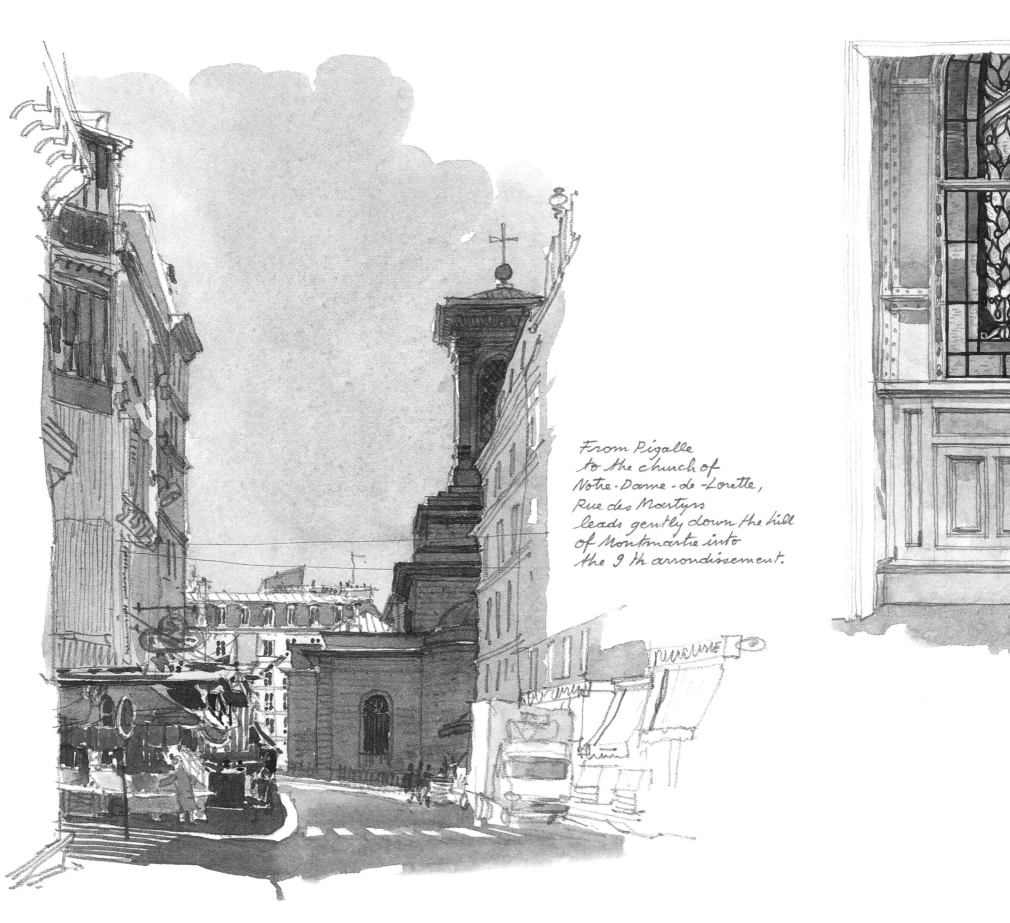

From Pigalle
to the church of
Notre-Dame-de-Lorette,
Rue des Martyrs
leads gently down the hill
of Montmartre into
the 9th arrondissement.

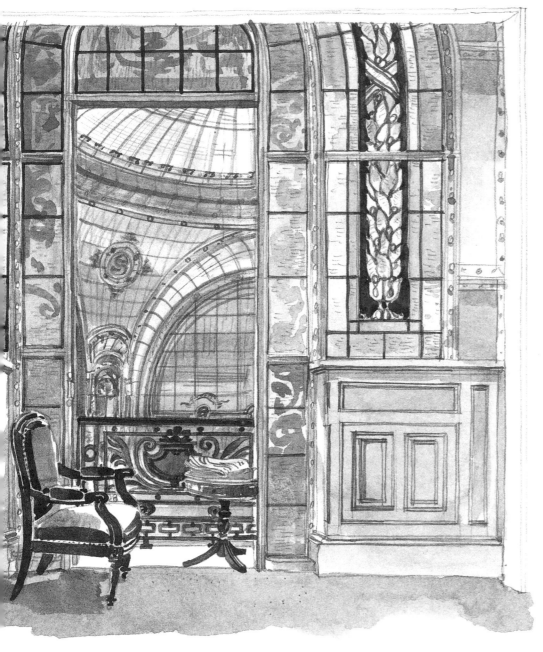

The stained-glass
windows and walls
of Société Générale
on Boulevard Haussmann,
one of the
Grands Boulevards.

The interior of the
auditorium of
the Opéra Garnier
is red and gold.

The world rediscovered the beauty of the Paris opera house
when the Opéra Garnier's façade was meticulously
restored in 2000. The building was commissioned by
Emperor Napoléon III and begun in 1863 by the architect
Charles Garnier. The façade alone includes 10 different
types and colors of marble. Garnier and his wife Louise
spent months travelling around Italy selecting the
marble and studying gilding techniques.

Northern Paris 59

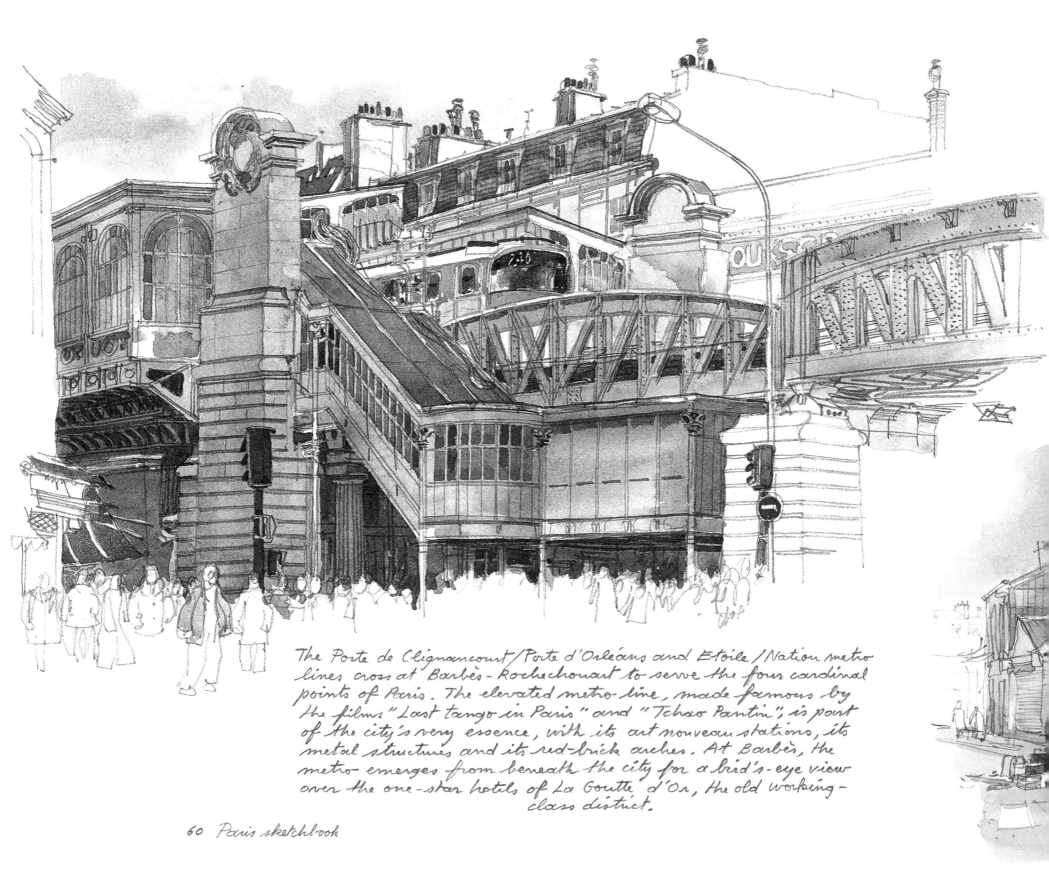

The Porte de Clignancourt/Porte d'Orléans and Etoile/Nation metro lines cross at Barbès - Rochechouart to serve the four cardinal points of Paris. The elevated metro line, made famous by the films "Last tango in Paris" and "Tchao Pantin", is part of the city's very essence, with its art nouveau stations, its metal structures and its red-brick arches. At Barbès, the metro emerges from beneath the city for a bird's-eye view over the one-star hotels of La Goutte d'Or, the old working-class district.

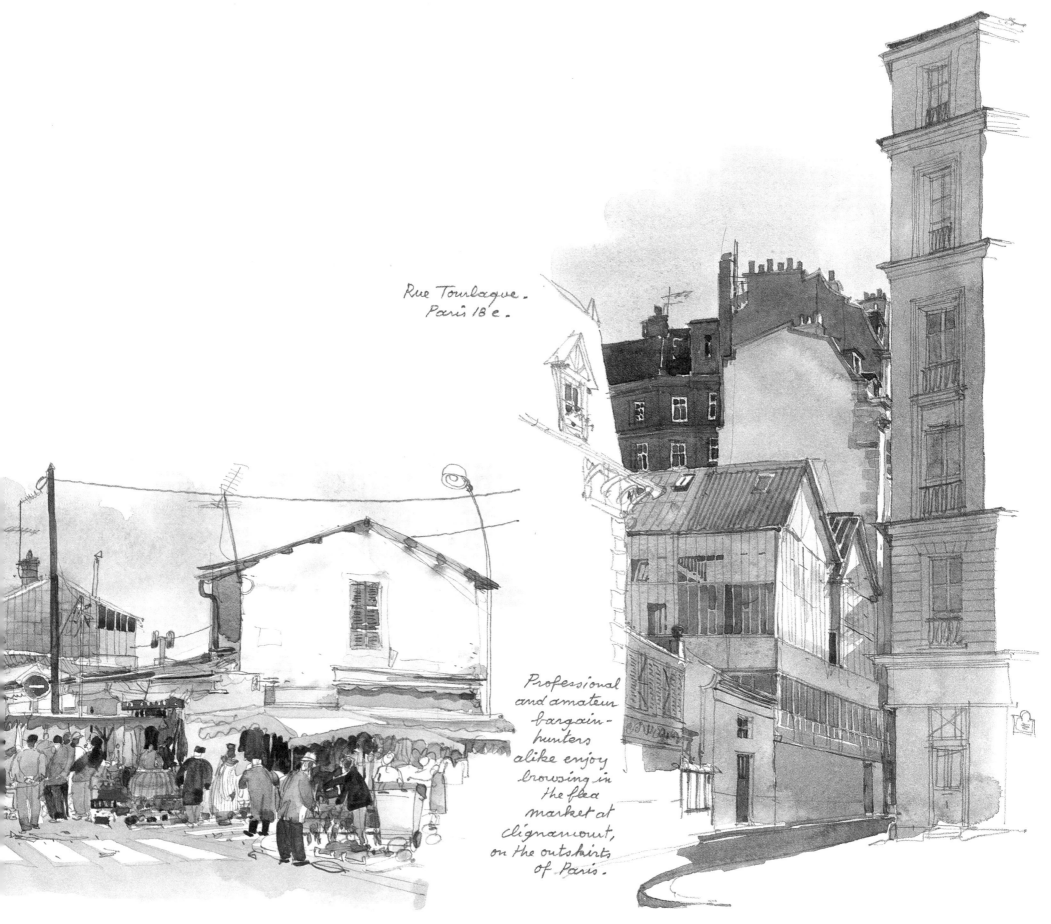

Rue Toulaque. Paris 18e.

Professional and amateur bargain-hunters alike enjoy browsing in the flea market at Clignancourt, on the outskirts of Paris.

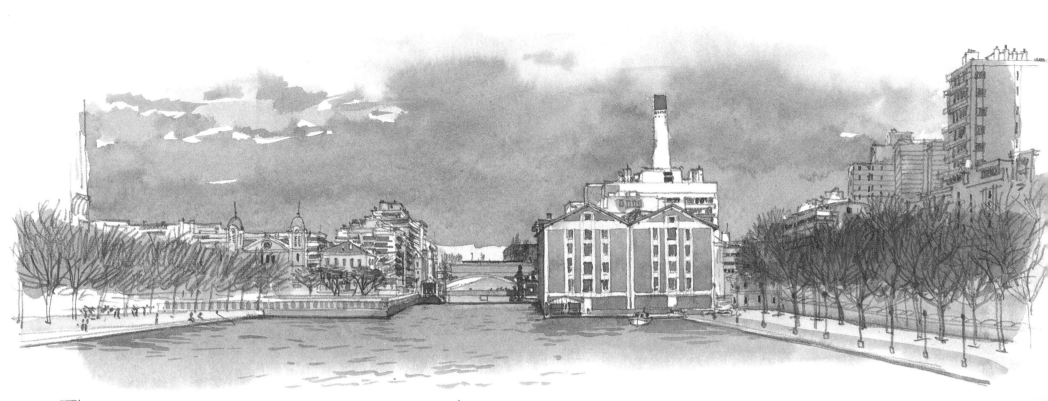

The 19th arrondissement is an unpretentious
residential area.
A view over La Villette Basin.

Lift bridge
on Rue de Crimée.
Paris 19e.

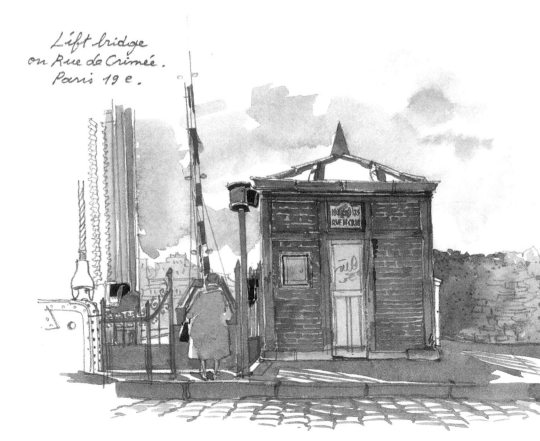

Canal Saint-Martin,
Canal de l'Ourcq,
La Villette Basin:
the locks and barges
have not changed
much since Jean Vigo's
1934 film "l'Atalante."
The waterways
in the north of Paris
have a different
aesthetic effect from
that of the majestic
and dominant Seine.
Here the water reflects
multicultural
neighborhoods,
old warehouses and
docks made of brick.
Industrial architecture
prevails.

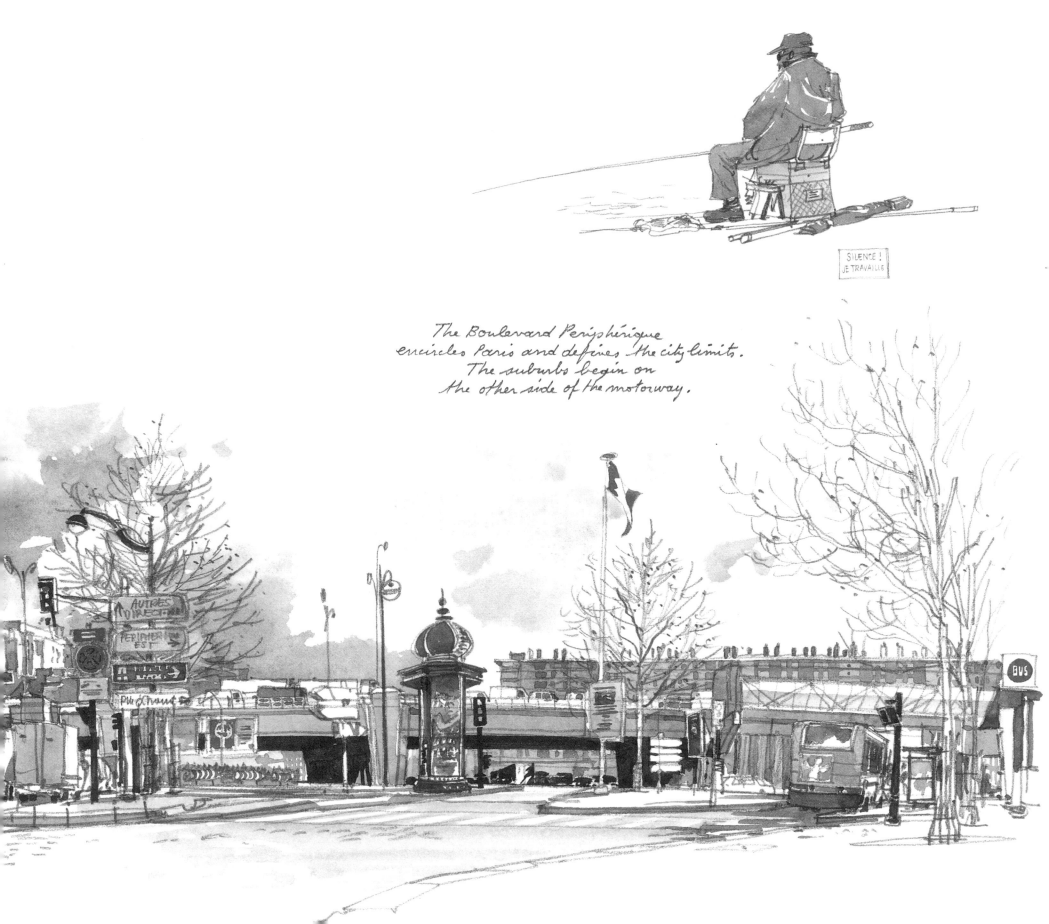

SILENCE !
JE TRAVAILLE

The Boulevard Périphérique
encircles Paris and defines the city limits.
The suburbs begin on
the other side of the motorway.

The Saint-Louis hospital
was built in 1607 just
outside the city walls so as to
keep people with the plague
away from healthy citizens.
It still looks the same today.

The Eurostar and the
Thalys cut through
the plains of Picardie
and Pas-de-Calais
at 300 km/h.
The high-speed trains,
a product of French
technology, have set
new standards for
rail travel.
In France, people
no longer refer to

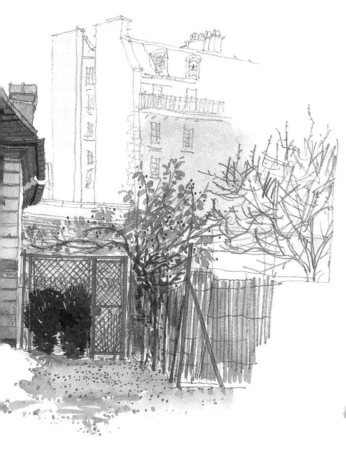

Atmosphere, atmosphere...
The neighborhood around the Canal Saint-Martin
is on the rise. Hôtel du Nord, once the
uncontested star of the quais, has recently
had some competition from the bars
and trendy restaurants in the area.
Écluse de la Grange-aux-Belles.
Paris 10 e.

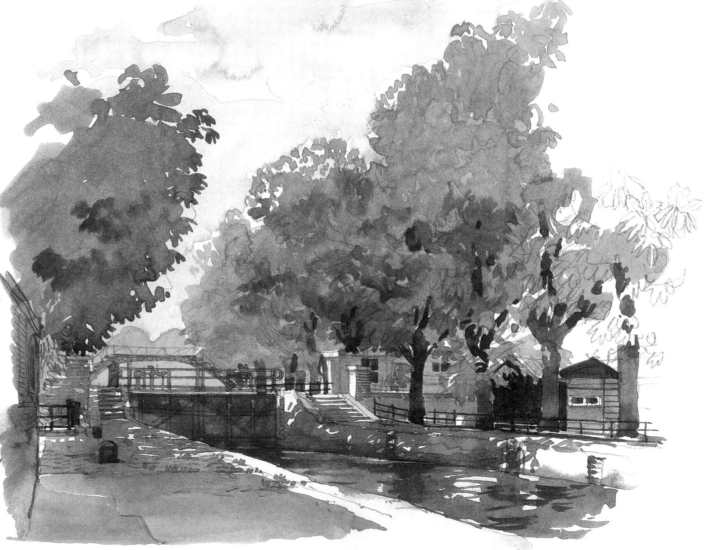

distances between cities in kilometers,
but in hours and minutes by TGV
(trains à grandes vitesses). London-
Paris, three hours. Brussels-Paris,
one hour and twenty minutes.
Thanks to the tunnel below the
English Channel and easier acces-
sibility than in the past, Britain
is gradually becoming less
isolated. Soon, the word "continental"
may be used only in hotels
to order breakfast.

Northern Paris 65

A temple, grottoes, stalactites, bridges, rivers, lakes, waterfalls, "forests" and an island can all be found in Parc des Buttes-Chaumont, one of the many parks laid out by Haussmann in the 1860's. Great for jogging and cycling, it is also a place to stretch out and relax. On sunny afternoons, families with children bring all sorts of toys, balls and dogs to play with while retirees sit on benches near the entrance and watch the fun.

On Sundays, the park is a
favorite escape from Paris
since it can be easily reached
without using the Périphérique
or getting stuck in traffic jams.
Just take the metro to Botzaris
or Buttes-Chaumont station and
plunge into the greenery.

Cité Tandelle,
Rue Rébeval, Paris 19e.

Eastern Paris

During the 19th century, the urban designer Richard Wallace created distinctive street-fountains that still bear his name.

Far from most of the major historic monuments and tourist attractions, the unpretentious 11th, 12th, 19th and 20th arrondissements have long been home to the city's working class. But eastern Paris also has a reputation for rebelliousness, supplying impassioned citizens for the storming of the Bastille in 1789 and the insurrection of the Paris Commune in 1871, which ended in a bloody standoff at Père Lachaise cemetery. These days, one is just as likely to see a young couple pushing a baby carriage or a weary professional with a laptop slung over his shoulder.

Belleville, the multiracial area around Boulevard de Belleville, has a concentration of Asian restaurants, thanks to all the Vietnamese and Chinese immigrants there. North African Muslims and Jews also live in the neighborhood, as do avant garde artists in need of affordable housing and the cachet that comes with "struggling." In recent years, the ethnic restaurants and bars around République, Oberkampf, Ménilmontant and Belleville have become trendy nightspots while the once-hot Bastille area is gradually being left to the out-of-towners. During the day, shoppers can still find some merchants grouped together by trade as they were centuries ago. On the side streets of Rue du Faubourg Saint-Antoine, for example, shoppers will find clusters of merchants specializing in lighting equipment or old-fashioned brass fixtures for doors and windows.

Meanwhile, the area is poised to meet the 21st century head-on with the new financial district and sports arena in Bercy and the high-tech arts and science complex at Parc de la Villette. At Place de la Bastille, the sleek new opera house, with its state-of-the-art backstage facilities, accommodates more people in better seating and for more performances than the Opéra Garnier. At Porte Dorée, the Musée des Arts Africains et Océaniens has fascinating collections of tribal art, including stunning African masks and statues. The 25-hectare Buttes-Chaumont Park provides a spacious green respite for all Parisians.

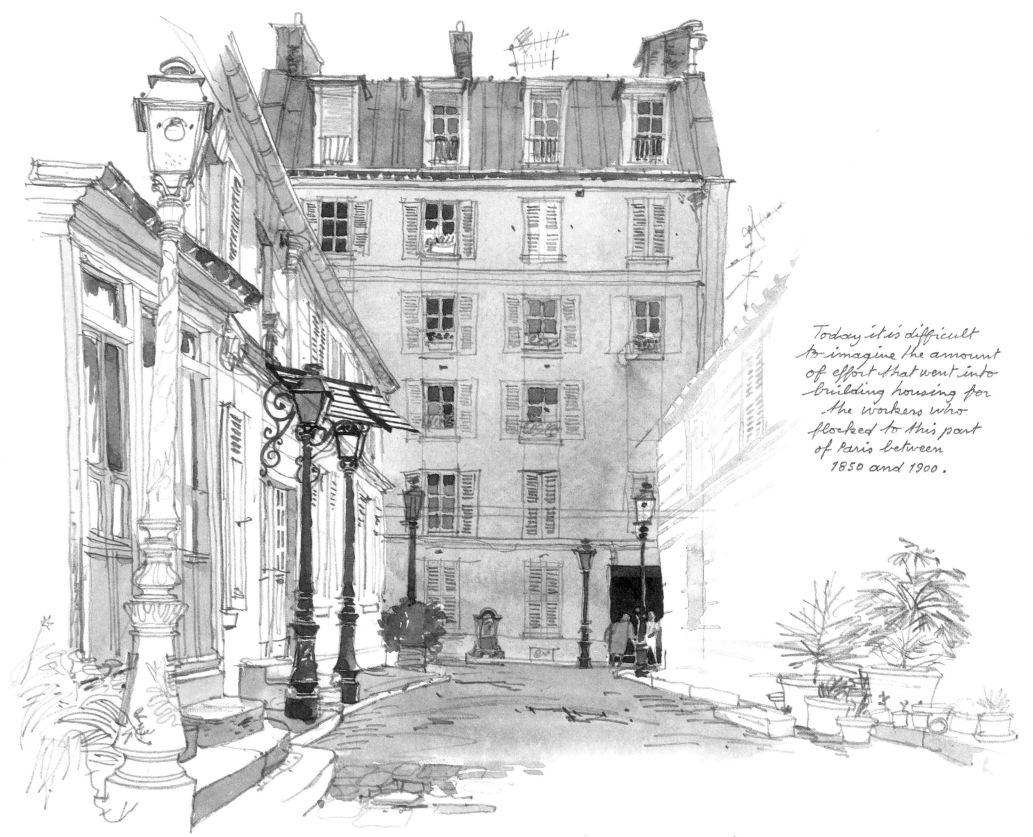

Today it is difficult
to imagine the amount
of effort that went into
building housing for
the workers who
flocked to this part
of Paris between
1850 and 1900.

Eastern Paris 69

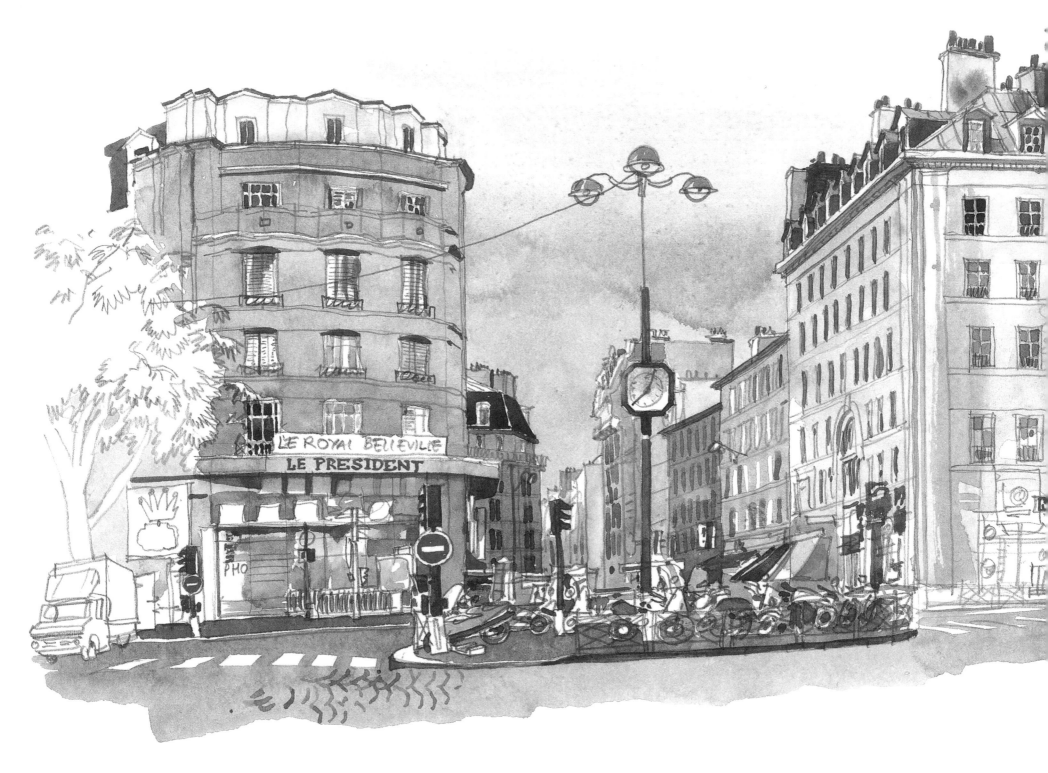

"Guinguet",
an ordinary little wine produced in
Belleville's own vineyards at the end
of the 19th century, was responsible
for drawing crowds of Parisians who came
to slum it with the locals in the lively
"guinguettes", dancing and singing
with scarves tied around their necks
and caps perched jauntily on their
heads. Today, large numbers of
immigrants live in this maze of
little streets.

Belleville
metro-station, 7 a.m.
The crowds have not
yet arrived.

When rents became excessive
in central Paris, blue-collar
workers headed to the unpretentious and
somewhat rebellious neighborhoods
of Belleville and Ménilmontant.
Rue Saint-Maur, towards
Rue Sainte-Marthe.

Grande Halle, Cité de la Musique. The work of two architects from two different epochs combines in the 30-hectare Parc de la Villette. Jules Mérindol (19th century) and Christian de Portzamparc (20th century) left their imprints on the themed children's gardens, halls and museums that make up this whimsical park in the north-eastern corner of Paris. Under the guidance of Adrien Fainsilber, a magnificent old slaughterhouse was converted into the Grande Halle, a glass, iron and steel structure that hosts theater performances, concerts and conventions. Across from it, the ultra-modern Cité de la Musique contains a triangular concert hall.

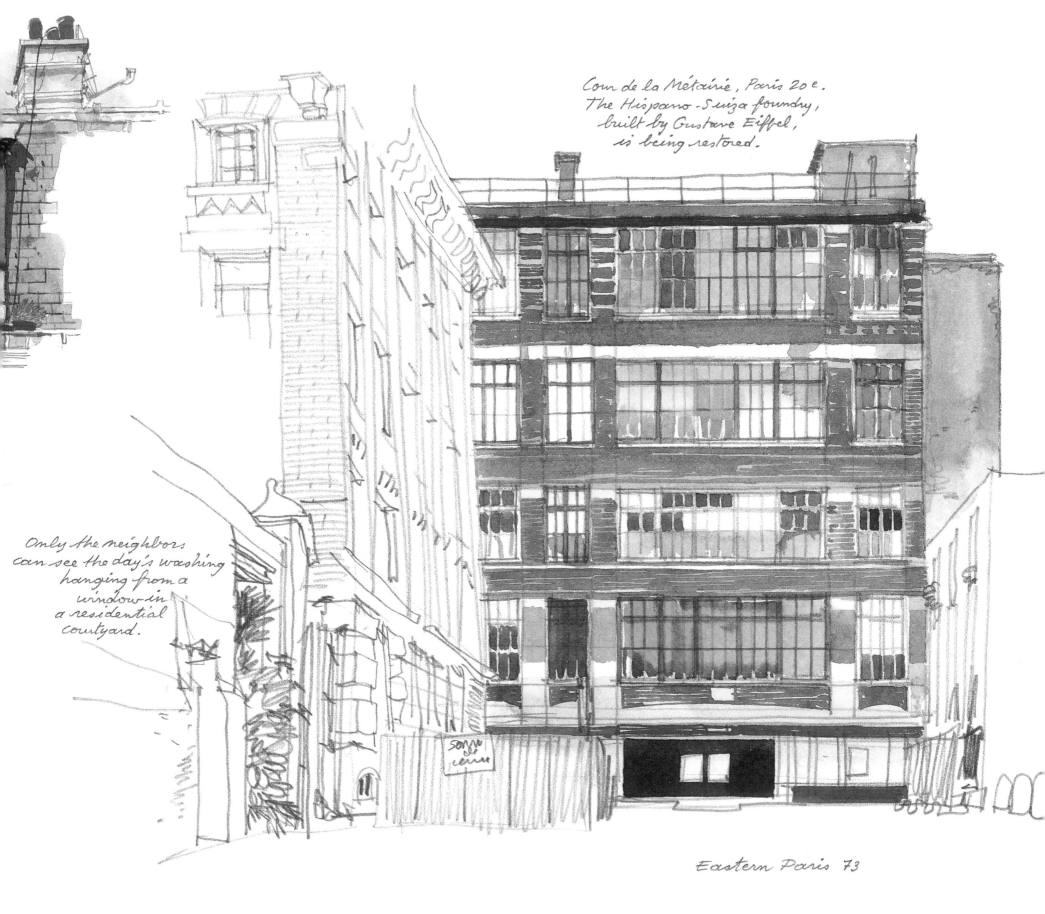

Cour de la Métairie, Paris 20e.
The Hispano-Suiza foundry,
built by Gustave Eiffel,
is being restored.

Only the neighbors
can see the day's washing
hanging from a
window in
a residential
courtyard.

Eastern Paris 73

Neo-Gothic style

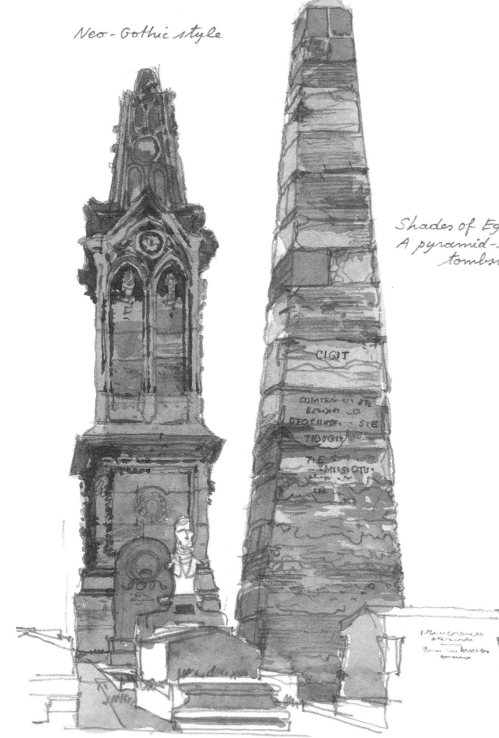

Shades of Egypt.
A pyramid-style
tombstone.

CI.GIT

COMTES DI JE
ERIXELO
DEOGILBER · SIE
TIGIBGIT

7i.ES
·MEISBIOTU·

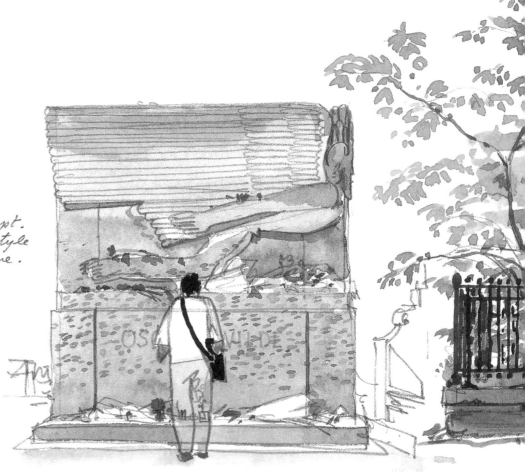

Oscar Wilde

Père-Lachaise Cemetery

Rue du Repos is the final address for Paris's
rich and famous after they die. Among the
poets, writers and artists buried here are Eugène
Delacroix, Balzac, Oscar Wilde, Gérard de
Nerval, Edith Piaf and Marcel Proust. But
this cemetery will never forget its bloody past.
Various stelae and mausoleums pay tribute
to insurgents who died for France. On May 28,

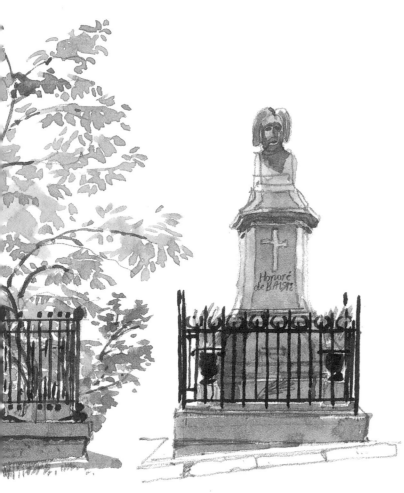

illegible Honoré de Balzac

1871, after an all-night battle in the
cemetery, the last surviving members of
the Paris Commune were lined up
against the south-east Wall of the
Federalists and shot by the government.
Curiously, the politician Adolphe Thiers,
arch-enemy of the Paris Commune,
is buried nearby.

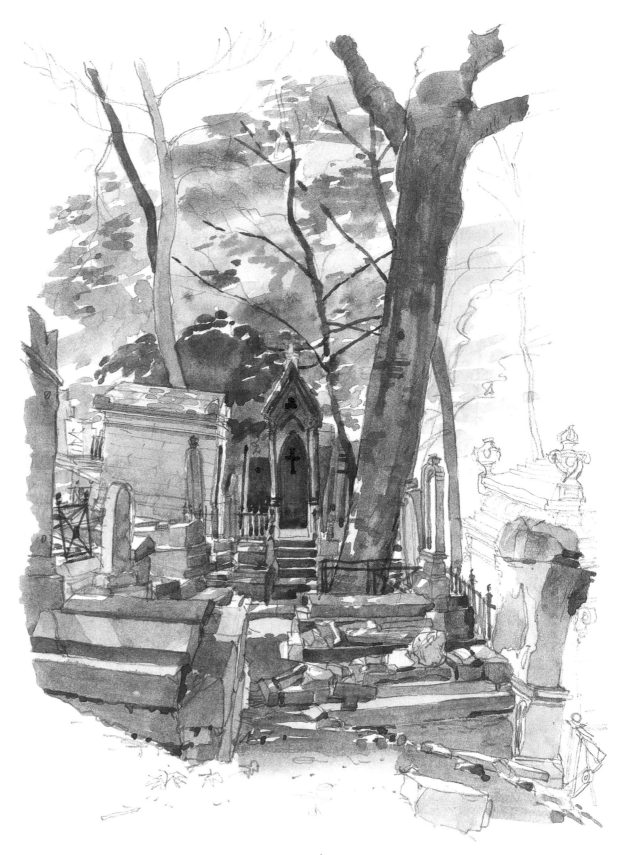

Eastern Paris 75

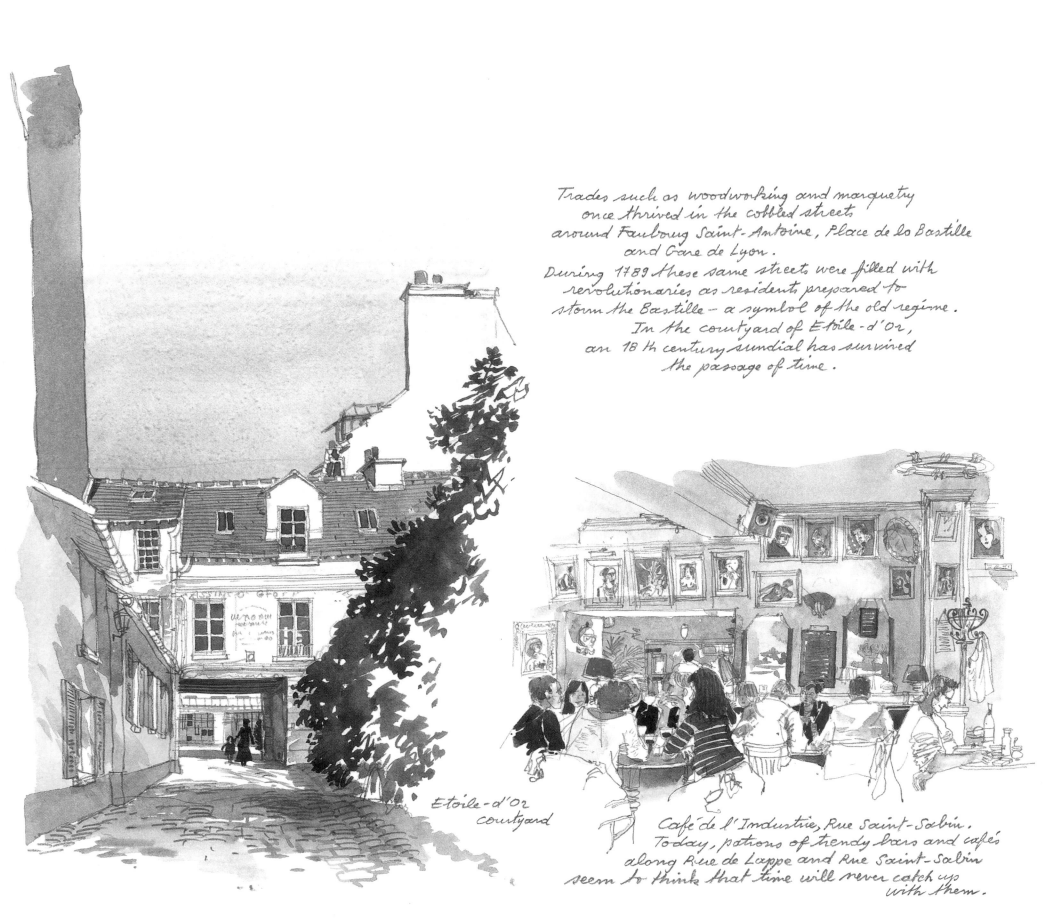

Trades such as woodworking and marquetry
once thrived in the cobbled streets
around Faubourg Saint-Antoine, Place de la Bastille
and Gare de Lyon.
During 1789 these same streets were filled with
revolutionaries as residents prepared to
storm the Bastille — a symbol of the old régime.
In the courtyard of Etoile-d'Or,
an 18th century sundial has survived
the passage of time.

Etoile-d'Or
courtyard

Café de l'Industrie, Rue Saint-Sabin.
Today, patrons of trendy bars and cafés
along Rue de Lappe and Rue Saint-Sabin
seem to think that time will never catch up
with them.

Passage du Chantier,
66 Rue du Faubourg Saint-Antoine,
Paris 11e.

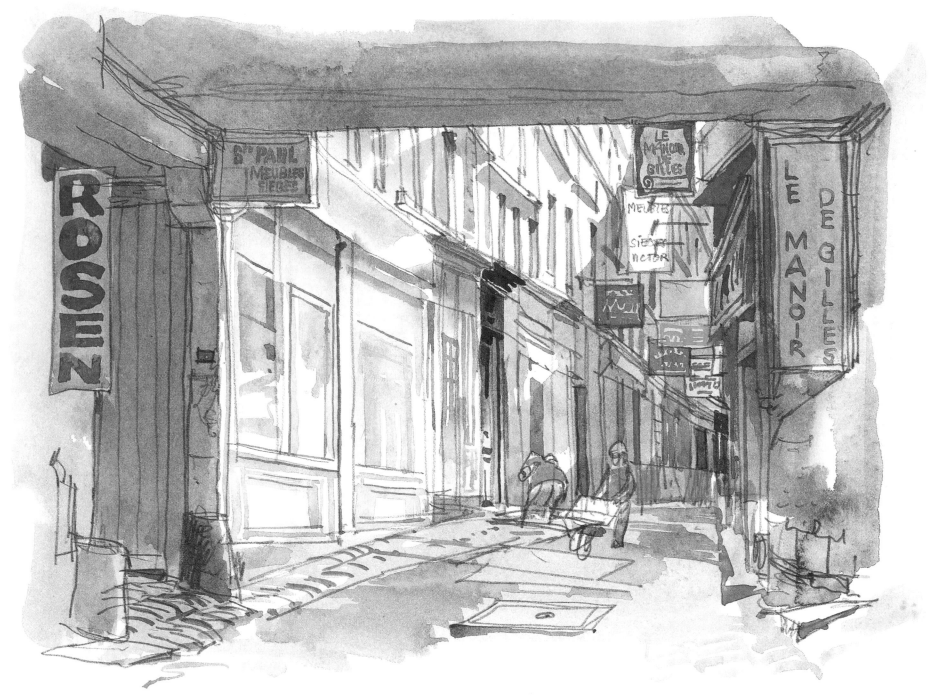

Eastern Paris 77

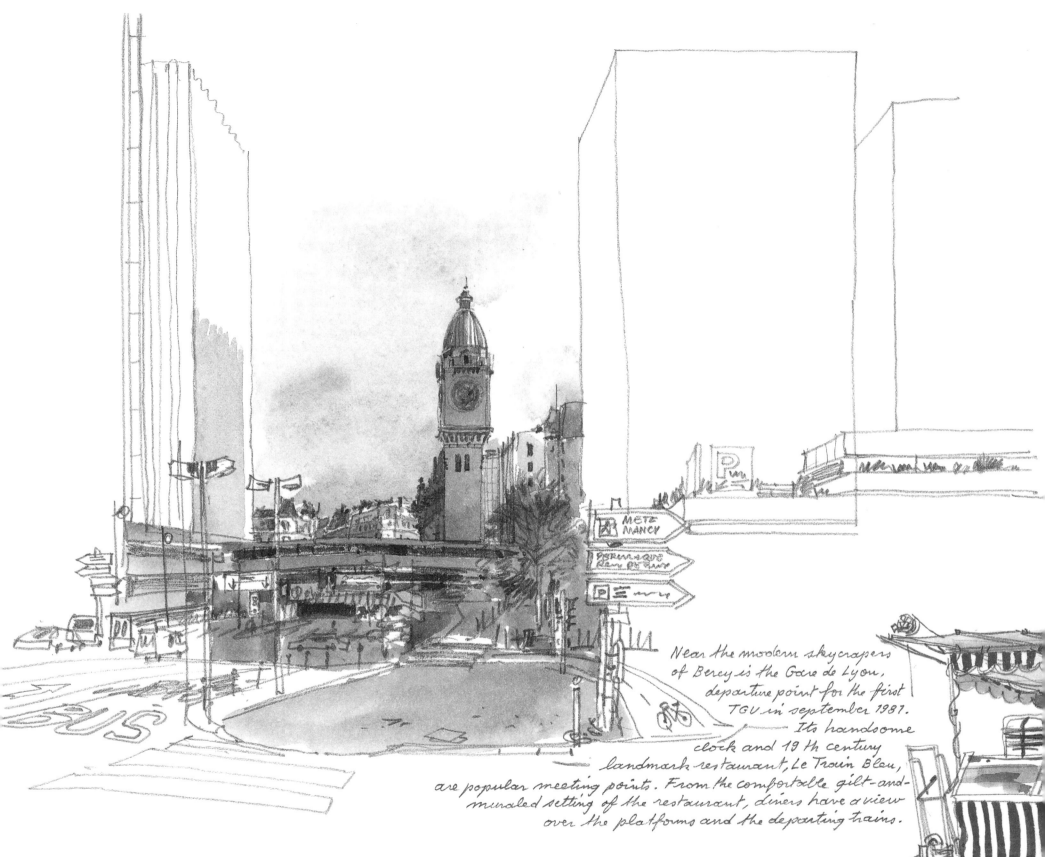

Near the modern skycrapers
of Bercy is the Gare de Lyon,
departure point for the first
TGV in september 1981.
 Its handsome
 clock and 19 th century
landmark restaurant, Le Train Bleu,
are popular meeting points. From the comfortable gilt-and-
muraled setting of the restaurant, diners have a view
over the platforms and the departing trains.

The fortress that once occupied the Place de la Bastille was stormed by angry mobs in July 1789 and later destroyed. In its place stands the July Column, which was erected in 1833 as a memorial to those who died during the July Revolution of 1830. Topped by a gilded figure of Victory, the greenish bronze pillar rises from a noisy traffic circle.

Richard Lenoir market (Thursdays and Sundays).

The National Library of France,
the grandest of the monumental buildings
commissioned by former President François Mitterrand, anchors the southeast
of Paris. Designed by architect Dominique Perrault to look like huge open books, the library's four
towers quickly became a familiar landmark of the left bank of the Seine during the 1990s. Across the
river is Bercy, once the home of the city's wine depots and now a gleaming new neighborhood housing
chic boutiques and restaurants, a park, the Palais Omnisports and the Finance Ministry.

F rom the Bibliothèque Nationale de la France, the national library, in the 13th arrondissement, to Paris Expo, the sprawling exhibition complex in the south-western corner of the 15th, the southern part of Paris sweeps beneath the inverted U of the Seine, hemmed in by the Boulevard Périphérique. Here is a swathe of city rich in contrasts. And while the celebrated squares and landmark buildings are less concentrated than they are closer to the Left Bank, they are no less cosmopolitan. Enormous Hong Kong-style eateries and smaller noodle shops draw Parisians from all over town to Tolbiac and Porte de Choisy in the 13th – the closest the city gets to a Chinatown. On a Sunday afternoon when most Parisian shops are dark, savvy cooks head for the aisles of the vast Asian supermarket, Tang Frères, for all sorts of fresh produce and exotic ingredients. Just to the west are the dormitories and lawns of the Cité Internationale Universitaire's campus; here foreign students live in "national" houses such as Casa de Cuba and Sweden House opposite the elegant Parc Montsouris. Taking a turn into the macabre, the stairs at Denfert-Rochereau descend into an underground ossuary where the bones and skulls of millions of Parisians are as artfully arranged in the maze of tunnels as rows of patisseries in a baker's shop.

In the northern part of the 14th and 15th arrondissements is Montparnasse, where the city's celebrated Bohemian past meets its modern present of steel, smoked glass and multiplex cinemas. For anyone keeping an eye on the calendar, a pilgrimage to one of the seasonal fairs at the Paris Expo may yield a crate of country cheeses or wines made by independent producers.

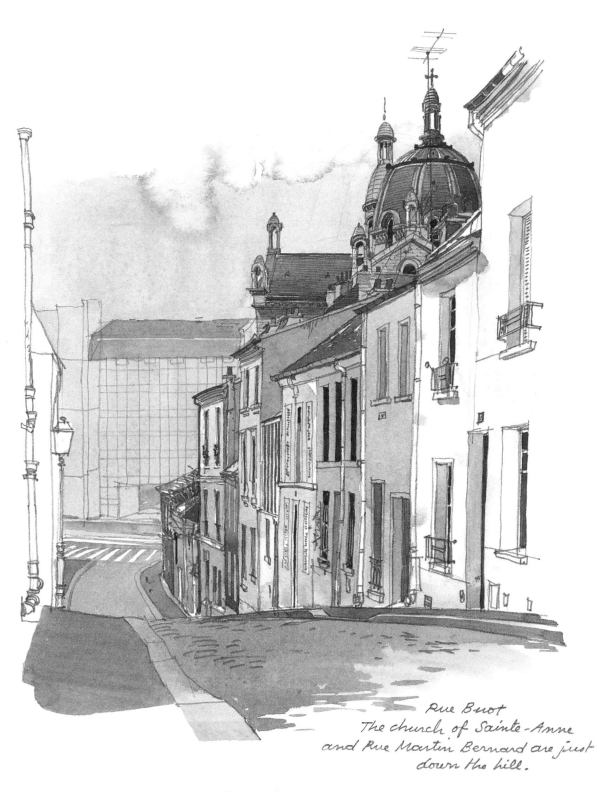

Rue Buot
The church of Sainte-Anne
and Rue Martin Bernard are just
down the hill.

Unlike Chinatown on the other side of
Avenue d'Italie in the 13th arrondissement,
La Butte-aux-Cailles is a colorful neighbor-
hood of charming two-story homes and
cheerful restaurants with painted shutters.
The atmosphere is like that of a small
village, where residents walk from the
café to the tobacconist, the bakery and
the grocer, and people greet each other
warmly on the street.

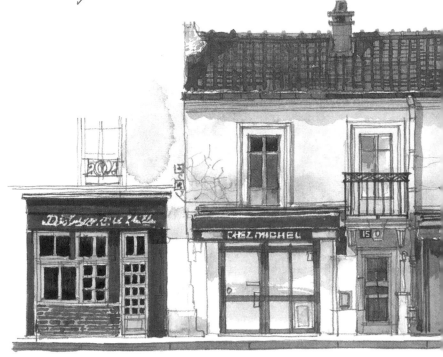

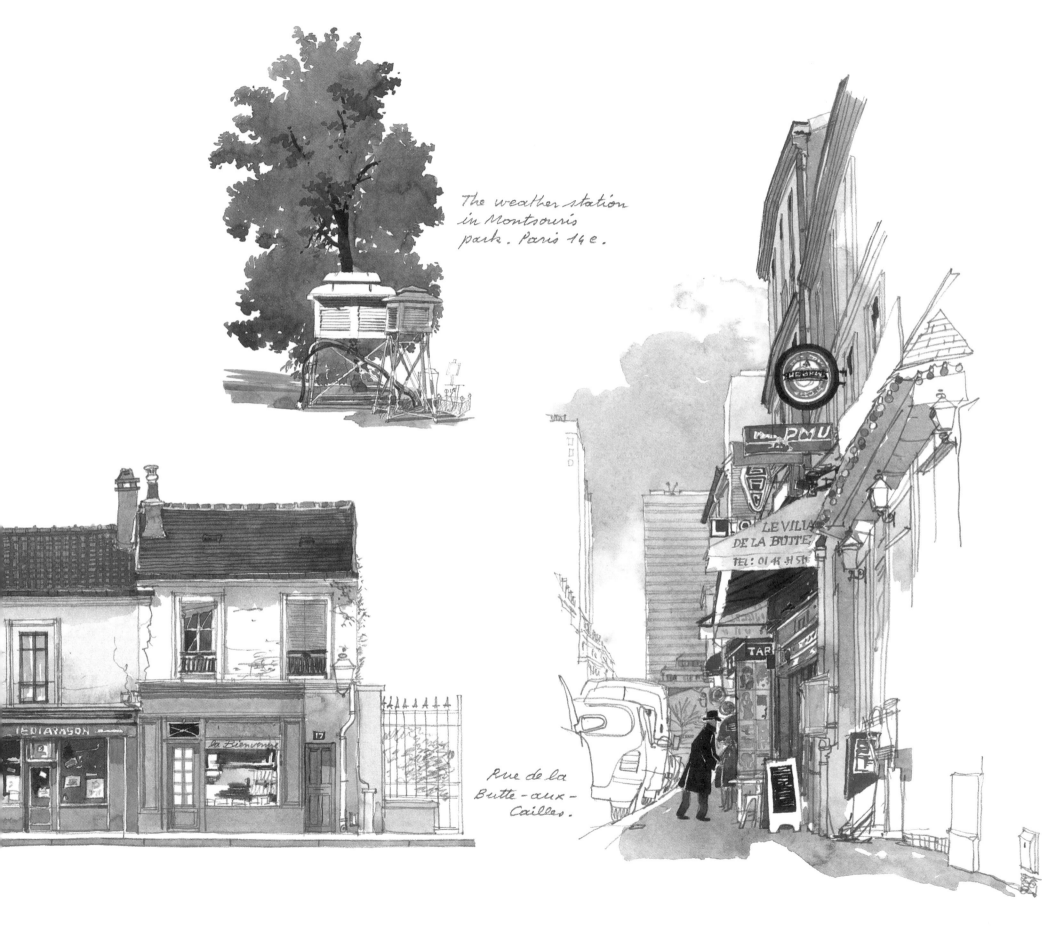

The weather station
in Montsouris
park. Paris 14e.

Rue de la
Butte - aux -
Cailles.

LE VILLAGE
DE LA BUTTE
TEL: 01 45 81 51

Every neighborhood of Paris has had its own
particularly memorable moments of history.
 At the start of the 20th century,
Montparnasse witnessed the arrival of the great
 Italian painter and sculptor Modigliani,
 who frequented the area's now-famous cafés,
La Rotonde and Le Dôme, with his friends Fujita,
Blaise Cendrars, and Soutine. Later, when Picasso
and Van Dongen moved in near Place Vavin, World
 War I was just around the corner. Modigliani,
 who suffered from tuberculosis and
 alcoholism, died just after Armistice Day,
 never imagining that one day the actor
 Gérard Philipe would recreate
 his life on film
 ("Montparnasse 19").

The Cartier Foundation by Jean Nouvel
was built on the site of the American
 Cultural Center, which itself had been
built on the spot where Chateaubriand once
lived. Behind the glass-and-steel walls
of the modern exhibition space is a live
cedar tree, planted by the early-19th-
 century author of
 "Mémoires d'outre-tombe".

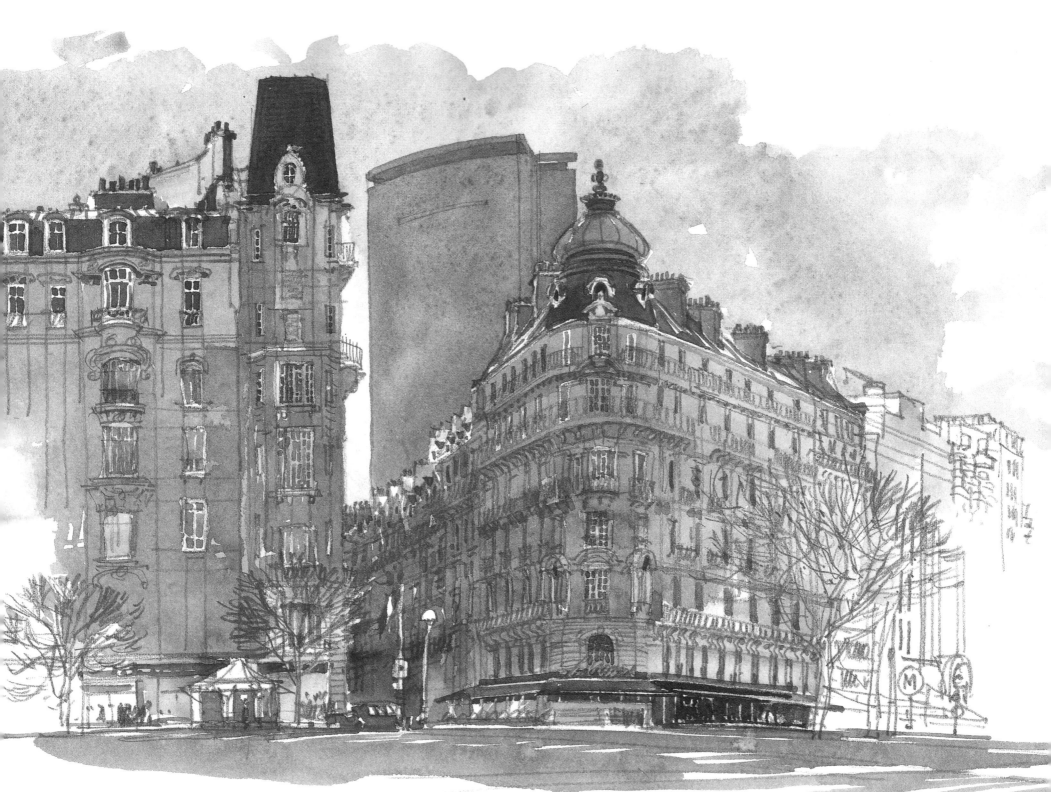

Café de la Rotonde on Boulevard du Montparnasse
and the tower of the same name in the
background. Built in 1973, the 209-meter-high tower was
the city's first skyscraper.

Southern Paris 85

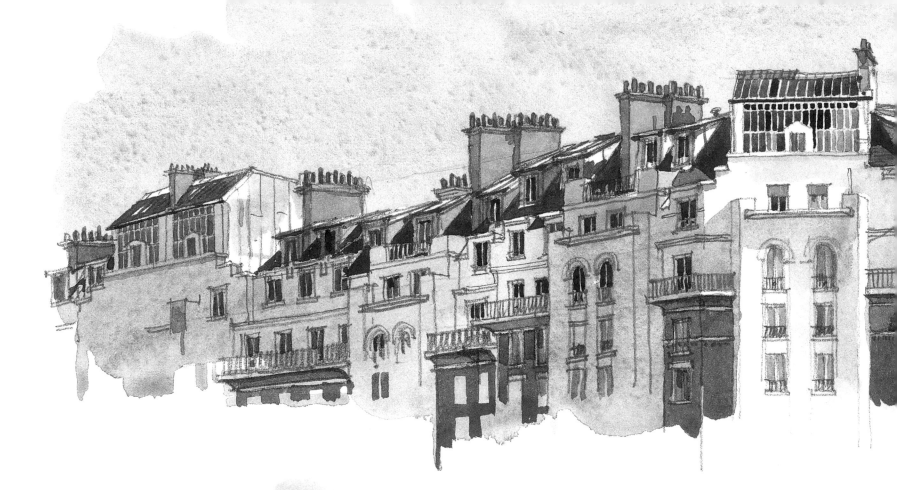

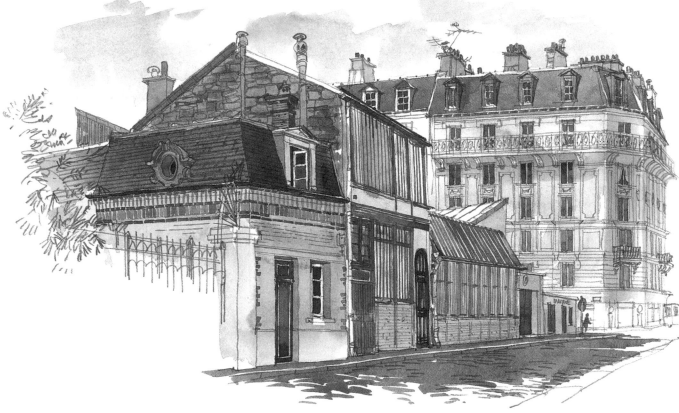

Calm, gardens and greenery preside at Villa d'Alésia, situated on one of the angled streets between Rue d'Alésia and Rue des Plantes. The din on nearby Avenue Général-Leclerc, which leads to the highway south, is a startling contrast.

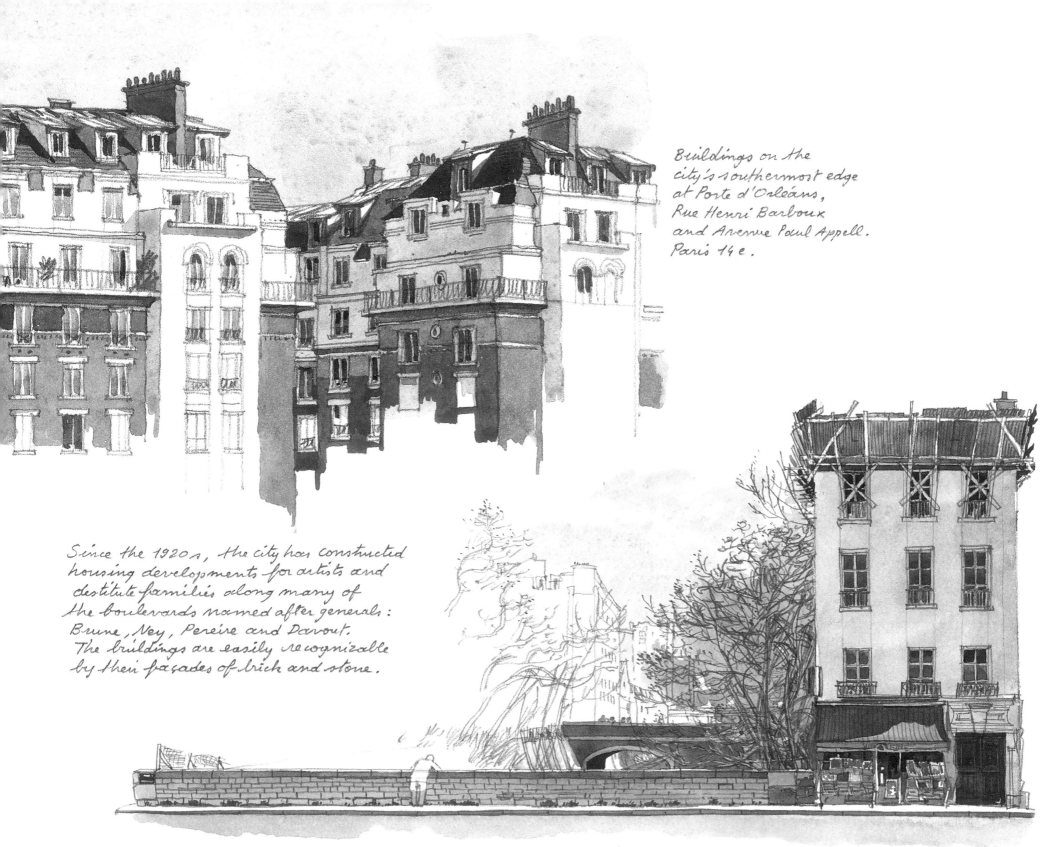

Buildings on the
city's southermost edge
at Porte d'Orléans,
Rue Henri Barboux
and Avenue Paul Appell.
Paris 14 e.

Since the 1920s, the city has constructed
housing developments for artists and
destitute families along many of
the boulevards named after generals:
Brune, Ney, Pereire and Davout.
The buildings are easily recognizable
by their façades of brick and stone.

A child leans forward over the Petite Ceinture bridge as if watching
an imaginary train.

Western Paris

In 1900, The engineer Fulgence Bienvenue created the Metropolitain and architect Hector Guimard brought his Art Nouveau style to stations. Porte Dauphine.

Seen from the 55-meter-high terrace on top of the Arc de Triomphe, the city's design is impressively clear. Shooting west from a glass pyramid at the Louvre to a modern arch at La Défense, the Voie Triomphale has evolved from its origins in the 17th century but it is still used for grand parades and processions – a tribute to its creators, and those who have enhanced it over the centuries. When Le Nôtre converted the empty fields of the Champs-Elysées into a park as an extension of the Tuileries, he could not have known that a World War I victory parade would march down it on July 14, 1919, or that 25 years later Charles de Gaulle would follow the same triumphal route at the end of World War II. Today, spectators line the 8th arrondissement's broad avenue every July to cheer the cyclists on the last leg of the Tour de France and revelers flock there to pop champagne corks on New Year's Eve and after major football victories. "The Champs" is now such a world-famous attraction that the pavements had to be widened at the end of the 20th century to their original width of 21 meters to accommodate all the shoppers and strollers, contemporary successors to the men and women of the 1800s who once promenaded here in horse-drawn carriages. One may lament the fast-food franchises, the cavernous record shops and crowds of tourists lining up to get into Louis Vuitton, but there's no denying the avenue's popular appeal. Napoléon I was surely conscious of the visibility he staked out for himself when he chose the head of the Champs-Elysées as the site for a colossal arch celebrating his military accomplishments. With 12 avenues radiating from it, the majestic Arc de Triomphe can be seen from areas far and wide, including the affluent residential neighborhoods of the surrounding 16th and 17th arrondissements.

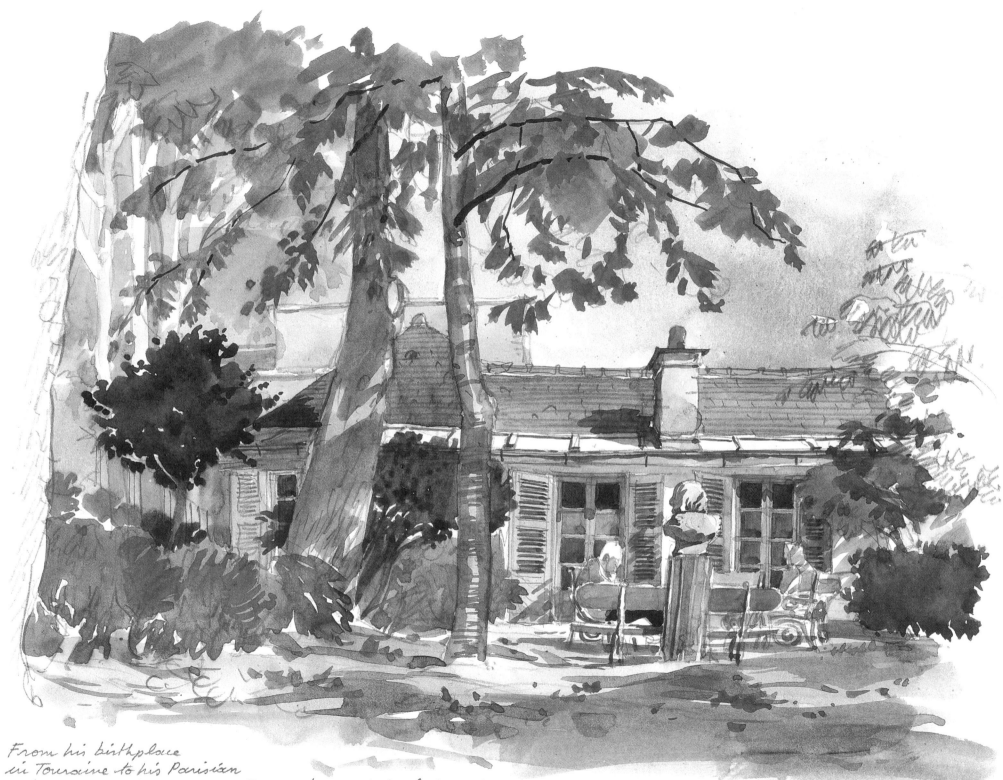

From his birthplace
in Touraine to his Parisian
refuge on Rue Raynouard, Balzac had nothing but praise
for his capital: " Paris is still that incredible marvel, a stunning
combination of movements, machines and other thoughts, city of 100,000
books, pinnacle of the world ".

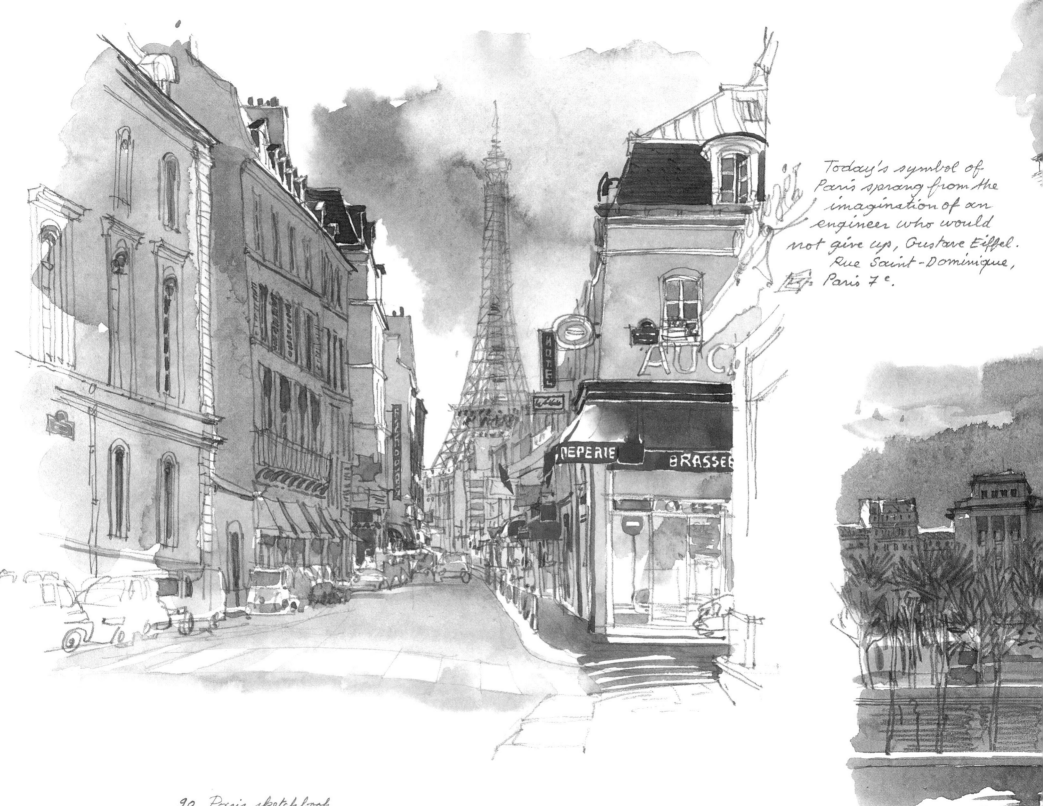

Today's symbol of
Paris sprang from the
imagination of an
engineer who would
not give up, Gustave Eiffel.
Rue Saint-Dominique,
Paris 7ᵉ.

Hector Guimard also left
his mark on the architecture
of the 16th arrondissement.
A devotee of Horta,
the grand master of Art
Nouveau in Brussels, he built
Castel Béranger on Rue La Fontaine
in a completely asymmetrical
style using cast iron, ceramic
and millstone. This street, where most of
the buildings are capped with small
slate domes, would eventually see
the birth of the great writer
Marcel Proust.

The Palais de Chaillot houses Jean Vilar's
Théâtre National Populaire and the
Cinémathèque of Henri Langlois.

Villa Beauséjour,
Paris 16e.

In the Parc Monceau, the white statue of
Chopin standing in front of his piano pays
homage to the musician.
Other sights in the park include an Egyptian pyramid-
the only remnant of the original park by Carmontelle,
a Corinthian column and a rotunda designed by Ledoux.
The park was built on the former site of the village
of Monceau, where Joan of Arc once set up camp.
Next door on Rue de Monceau, the
mansion that once belonged to a banker
named Camondo has become a museum.

These gilded and
engraved gates by Ducros
are the perfect symbols
of this elegant
neighborhood.
Faubourg Saint-Honoré,
with its fine jewelry
shops and fashion
houses, is not far
away, not to mention
the Elysée palace,
official residence
of the President
of France.

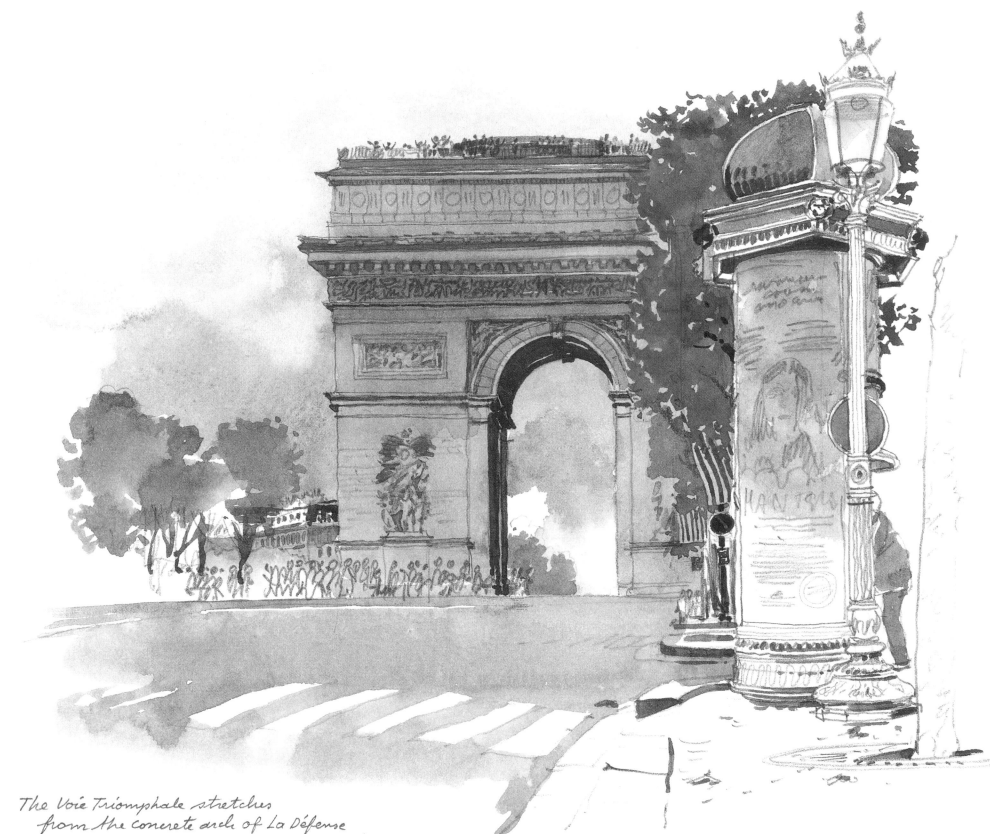

The Voie Triomphale stretches
 from the concrete arch of La Défense
to the glass pyramid of the Louvre, with the
 Arc de Triomphe in the middle.

Western Paris 93

Gazetteer

Arc de Triomphe

The monument was commissioned by Napoleon I in 1806 to celebrate the glories of the French army. Designed and begun by Jean-François Chalgrin, who died in 1811, it was completed under Louis-Philippe in 1836.
Place Charles-de-Gaulle (pp. 88, 93).

Arc de Triomphe du Carrousel

A copy of the Arch of Septimus Severus in Rome, although smaller in size, it was commissioned by Napoleon I in 1806 to commemorate his victories of 1805. Designed by Fontaine and Percier, it was completed in 1808.
Between the Louvre and the Tuileries gardens (p. 20).

Arènes de Lutèce

A 2nd-century Roman amphitheater discovered in 1869.
49 Rue Monge (p. 7).

Assemblée Nationale, Palais Bourbon

Only the inner courtyard and main entrance remain from the original mansion built on this site for the dowager duchess of Bourbon in 1728. The neo-Hellenistic northern façade was added in 1807 to balance the Madeleine across the river. 33 Quai d'Orsay (p. 25).

Basilique du Sacré Cœur

The construction of the church was decreed by the National Assembly in 1873 as an act of contrition after the humiliating Franco-Prussian War of 1870–71. The Romanesque-Byzantine design is by Paul Abadie. The building was consecrated in 1919.
Place du Parvis-du-Sacré Cœur, (p. 54).

Bibliothèque Nationale de France

Grandest of the monumental buildings commissioned by Président François Mitterrand in 1989. Designed by architect Dominique Perrault, it was opened in 1998.
11 Quai François Mauriac (p. 80).

Le Bouillon Racine

Art Nouveau brasserie near Odéon, now classified as a historic monument. 3 Rue Racine (p.46).

Cartier Foundation

Contemporary art exhibition space and offices for Cartier. Completed by Jean Nouvel in 1994.
261 Boulevard Raspail (p. 84).

Centre National d'Art et de Culture Georges Pompidou

Commissioned by President Georges Pompidou in 1969, the avant-garde design is by Renzo Piano and Richard Rogers. It was completed in 1977.
Place Beaubourg (pp. 13, 36–7).

Conciergerie

Constructed in the 14th century as a royal palace, it includes three magnificent Gothic-style rooms built for servants and attributed to Philippe le Bel. The building was later restored and used as a prison, notably in the 18th century. 1 Quai de l'Horloge (p. 30).

La Coupole

Brasserie with art deco décor. Established at the end of 1927, it was decorated by some 30 painters. Recently renovated, it is a popular hangout for celebrities and tourists. 102 Boulevard du Montparnasse (p. 14).

Le Fouquet's

This was the leading restaurant on the avenue des Champs-Elysées during the 19th century, when it was known as the Criterion. It became "Le Fouquet's" in 1901. Journalists and show business people figure prominently in the clientele. This area is associated with the French cinema world. 99 Avenue des Champs-Elysées (p. 14).

Grand Palais

This great structure, with its classical façade and art nouveau-style glass roof, was built for the 1900 World Fair. It is used to house large exhibitions. The western part is dedicated to the Palais de la Découverte – the "Palace of Discovery". 1–3 Avenue du Général Eisenhower (p. 53).

Grande Arche, La Défense

The arch marks the western end of the Voie Triomphale. Commissioned by President François Mitterrand, it was designed by Otto von Spreckelsen, and inaugurated in 1989.
Esplanade du Général de Gaulle, Paris-La Défense (p. 21).

Grande Halle and Cité de la Musique, La Villette

Under the guidance of Adrien Fainoilber, a magnificent old slaughterhouse was converted into the Grande Halle, a glass, iron and steel structure that, since 1985, has hosted theater performances, concerts and conventions. The Cité de la Musique nearby houses a triangular concert hall, as well as a museum of music, a library and other facilities. These are two of a range of leisure, scientific and arts facilities in the park of La Villette.
21 Avenue Jean Jaurès (p.72).

Grande Mosquée

Built in a Hispano-Moorish style, it was begun in 1922, and inaugurated in 1926. Place du Puits-de-l'Ermite (p. 38).

Harry's Bar

Famous watering hole notable for its mid-19th-century Cuban mahogany interior. 5 Rue Daunou, 2e (p. 14).

Hôpital Saint-Louis

The institution was founded by Henri IV. The building, by Claude Vellefaux, was constructed in 1607–12, and is a fine example of early Louis XIII style.
1 Rue Claude Vellefaux (p. 64).

Hôtel de Cluny.

Built in 1490 by Abbot Jacques d'Amboise as a town house for the abbots. It is the best example of medieval domestic architecture in Paris. Today it houses the Musée du Moyen Age. 6 Place Paul Painlevé (p. 19).

Hôtel des Monnaies

Constructed by J.-D. Antoine in 1772-5. It became the royal mint under Louis XV, and now houses the Musée de la Monnaie. 11 Quai de Conti (p. 29)

Hôtel de Ville.

Paris's city hall. Built in 1874–82 in French Renaissance style from the plans of Ballu and Deperthes, it is a replica of the original building begun in 1532 which was burned down by the Communards in 1871.
Place de l'Hôtel-de-Ville, 4e (p. 25).

Institut de France

The Institute was created in 1795 as a grouping together of several older-established bodies, the Académie Française being the most famous. The building was constructed in the 17th century on a plan devised by Le Vau, the greatest architect of Louis XIV's reign. 23 quai de Conti, 6e (p. 25).

Institut du Monde Arabe

Commissioned by President François Mitterrand, it was completed in 1987. The architect was Jean Nouvel.
1 Rue des Fossés St-Bernard (p. 43).

Mayenne Mansion

Work on this building in the Marais, built in brick and stone, in the style of Louis XIII, was begun in 1606 by Charles de Lorraine, Duke of Mayenne. During the course of the work his son Henri transformed it with the architect Androuet du Cerceau. Today it is in the course of restoration. 21 rue Saint-Antoine (p. 35)

Métropolitain ("Métro") station

Engineer Fulgence Bienvenue and architect Hector Guimard brought Art Nouveau to many stations of the Métro, including this 1900 example. Porte Dauphine (p. 88).

Musée des Arts Africains et Océaniens

Built between 1928 and 1931 by the architects Jaussely and Laprade for the Exposition Coloniale of 1931. The façade is decorated with numerous sculptures.
293, Avenue Daumesnil (p. 68).

Musée du Louvre

Built around 1200 as a fortress, under Philippe Auguste. In 1528, François I had it transformed into a palace. It was the residence of the monarch and of the court until 1678. In 1793, it became a museum; and in the 19th century, it was restored and enlarged (a new wing was built on the rue de Rivoli). In 1981 it was reorganised, with the addition of the Pyramid constructed by I M Pei (p. 20).

Musée de Montmartre

Home of the actress Rose de Rosimond in 1680. In 1922, it was bought by the town of Paris, to be turned into a museum of the history and archeology of old Montmartre. 12 Rue Cortot (p. 56).

Musée du Jeu de Paume

Built in 1861 by order of Napoleon III. Today it hosts temporary exhibitions of contemporary art. In the Tuileries garden, beside the Place de la Concorde (p.24).

Musée d'Orsay

This former station was built in 1900, and functioned as such until 1939. Conversion into a museum was completed in 1986 under the architect Bardon. The museum is dedicated to the art of the 19th century. Quai Anatole France (p. 52).

Notre Dame

In 1160 Sully, Bishop of Paris, decided to have a new cathedral built over the remains of an ancient basilica. Construction was completed at the beginning of the 14th century. The cathedral sustained considerable damage during the French Revolution, and was restored in the 19th century by Viollet-le-Duc. Place du Parvis Notre-Dame (p. 31).

Opéra Bastille

The Bastille opera house was commissioned by President François Mitterrand. Completed by Carlos Ott in 1989 to mark the 200th anniversary of the storming of the Bastille and to bring opera to a wider audience. 2-6 Place de la Bastille (p. 68).

Opéra Garnier

This elaborate example of Second Empire architecture was commissioned by Emperor Napoleon III and begun in 1863 by Charles Garnier. It was completed in 1875. Place de l'Opéra (pp. 54, 59).

Palais de Chaillot

Built for the 1937 World Fair by Carlu, Boileau and Azéma in the Art Deco style. 17 Place du Trocadéro (p. 91).

Palais de Justice

The complex that houses the municipal law courts also encompasses the Conciergerie and Sainte-Chapelle. The site of an administrative center during Roman times, it expanded over the centuries. It was rebuilt in the 19th century by Duc and Daumet. 4 Boulevard du Palais (p.30).

Panthéon

King Louis XV commissioned the church of St Genevieve from the architect Jacques Germain Soufflot in 1757. The plan of the church is a Greek cross. The building was finished in 1790. The following year, during the French Revolution, it was transformed into a mausoleum for the "grands hommes", or great men, of French history. Victor Hugo and Andre Malraux are two of them. Place du Panthéon (pp. 18, 42).

Père Lachaise cemetery

Laid out on the old hill of Champ l'Evêque, and named after the confessor of Louis XIV, this huge cemetery contains the final resting place of many famous people, including many from the world of literature and the arts. The first interments were those of the writers La Fontaine and Molière, whose remains were transferred here in 1805 (pp. 74–5).

Place de la Concorde

Formerly named Place Louis XV, this is one of five "royal" squares in Paris. The perfectly rectangular shape is well-suited to the austere lines of the two palaces designed by Jacques-Ange Gabriel. Place de la Concorde (pp. 22–3).

Place des Vosges

Another of the city's five "royal" squares, it is surrounded by arcades and 36 symmetrical houses. It was designed for Henri IV probably by Baptiste du Cerceau as a fashionable area to live, and inaugurated in 1612. The original name was Place Royale. Place des Vosges (p. 34).

Pont Neuf

Paris's oldest bridge, it was begun in 1578 by Androuet du Cerceau, and inaugurated in 1607 by Henry IV. It crosses from the 1st to the 6th arrondissement via Ile de la Cité (p. 29).

Pyramide

Commissioned by President François Mitterrand, it was designed by Ieoh Ming Pei and completed in 1990. Cour Napoléon, Le Louvre, (p. 27).

Ritz Hotel

Founded in 1898 by César Ritz, the hotel is fitted out largely in the style of the end of the 18th century. 15 Place Vendôme (p. 14).

Sainte-Chapelle

Built in 1248 by King Louis IX as a royal chapel and repository for precious religious relics, including the Crown of Thorns. This masterpiece of Gothic architecture with superb stained glass windows was designed by Pierre de Montreuil. 4 Boulevard du Palais, Ile de la Cité (p. 23).

Saint-Etienne-du-Mont

A church of great individuality, built in the Gothic style of the end of the 15th century, with a Renaissance façade (early 17th century). Place Sainte-Genevieve (p. 40)

Saint-Gervais

Built between 1494 and 1620, the church is in the "flamboyant" Gothic style of the late 15th century with an early-17th-century Renaissance-style façade. Place Saint-Gervais (p. 33).

Sully Mansion, Le Marais

The Duc de Sully, minister under Henry IV, bought the mansion after its construction. Built in the form of a U, the two wings enclose a ceremonial courtyard. This is the headquarters of the Caisse Nationale des Monuments Historiques, the body charged with the care of the country's built heritage. 62 rue Saint-Antoine (p. 35)

Tour Eiffel

The Eiffel Tower was begun in 1884 and completed in 1889 for the World Fair by Gustave Eiffel. It also commemorated the centennial of the French Revolution. It is a masterpiece of both architecture and engineering. Including the television equipment on top, it is 319 meters (approx. 1050 feet) high. Quai Branly (p. 90).

Tour Montparnasse

The 209-meter-high tower was Paris's first skyscraper. It was built in 1973 as part of an urban renewal project for the Maine-Montparnasse area conceived by Raoul Dautry. 33 Avenue du Maine (p. 85).

Val-de-Grâce

Among the best preserved examples of 17th century architecture in Paris, the church was commissioned by Anne of Austria in thanks for the birth of Louis XIV in 1638. It was completed in 1667. The Roman-Baroque dome is by Gabriel Le Duc. The façade was designed in Counter-Reformation style by François Mansart. Rue St. Jacques, Place A. Laveran (p. 14).

The lake at Bois de Vincennes.